365 DAYS OF

KAWAii

How to Draw Cute Stuff Every Day of the Year

MAYUMI JEZEWSKI

EASY STEP-BY-STEP DRAWING

DAVID & CHARLES

www.davidandcharles.com

KAWAII DRAWING SECRETS!

PROPORTIONS

To give the characters a cute look, the head must be much larger than the body. The body should be small and short. If the body is measured as one unit, the head should be two and a half units.

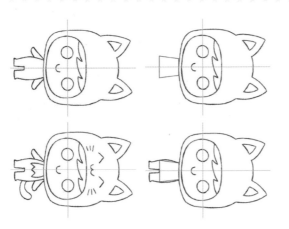

THE BODY

Extend the centre line of the face to the level of the feet. Starting with a simple shape, sketch the body and add other elements like arms, legs and tail.

THE HEAD

Start by drawing a simple geometric shape, such as a circle in this example, then trace the axis of the eyes and the centre line of the face. These will serve as landmarks to place the eyes, the mouth and the rest of the elements of the face.

HANDS AND FEET

Hands and feet are very simple and without real fingers. If you wish, you can detail them a little more while keeping them rounded with simple proportions.

hands

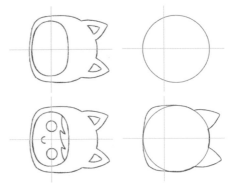

feet

OUTLINES

The outlines are often thick. To draw them, use a permanent felt tip pen that does not smudge when colouring. You can use finer felt tip pens on other elements to create contrast or to mark certain details. In this example, the cat's face and the character's mouth are thinner than the other outlines.

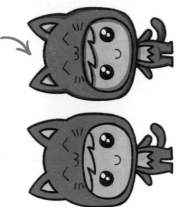

shadows

ADDING COLOUR

In kawaii we usually use solid colors, but you can add some simple shadows to give depth to the characters without worrying about realism. Use different marker colours to fill the solid areas and similar but darker shades to add the shadows.

In this book, you will find a huge range of drawings! To help you navigate, you'll find a symbol at the top of each page to indicate the theme.

🐾 Animals ❌ Food 🚗 Transport

🍃 Plants ⬅️ Household Objects 🌐 Around the World

🐚 Characters

FACIAL EXPRESSIONS

The expressions are simplified and are distinguished by the absence of a nose. There are so many variations that will give personality to your characters! Which one do you like best?

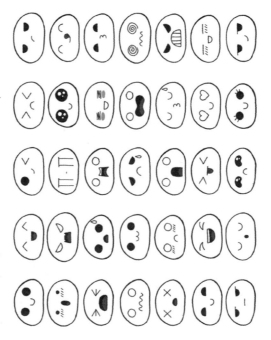

Bee

☆ ☆

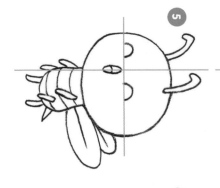

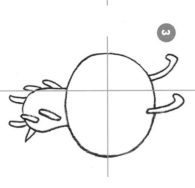

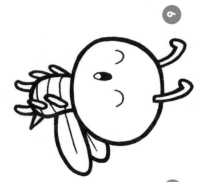

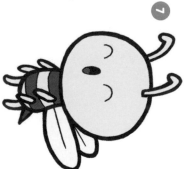

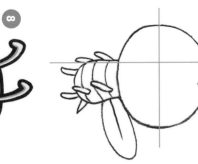

☆ Beehive ☆

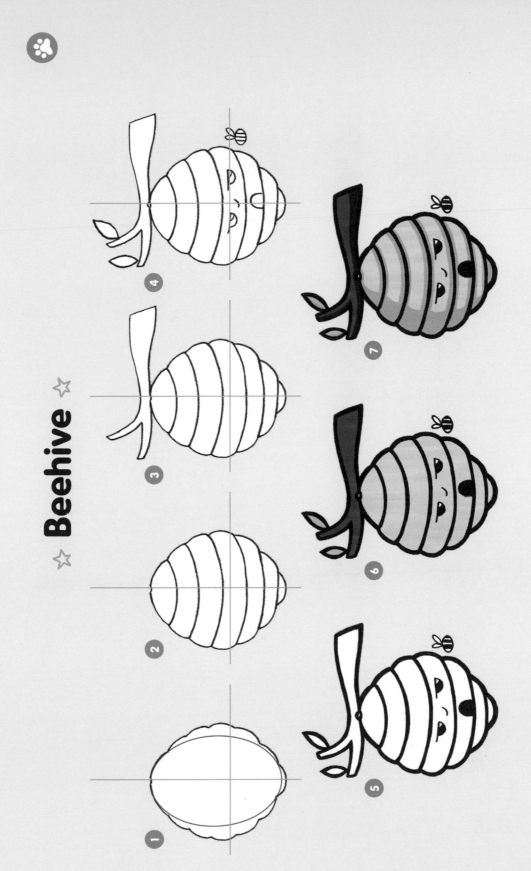

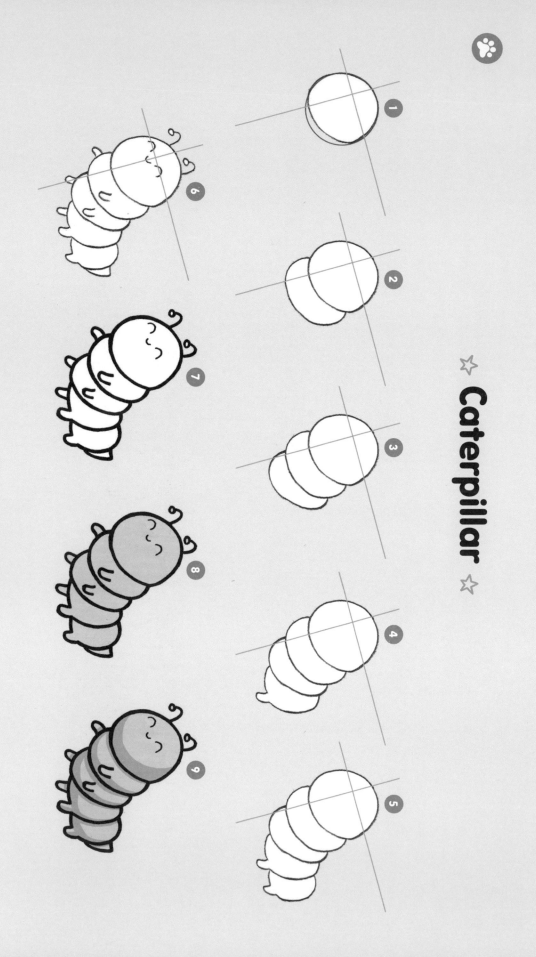

Caterpillar

☆ Butterfly ☆

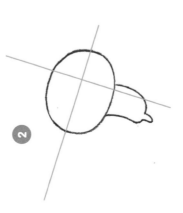

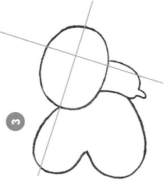

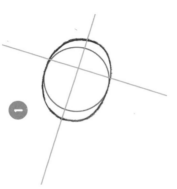

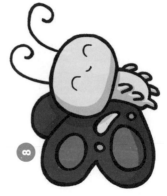

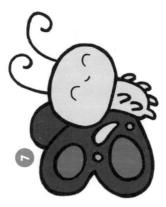

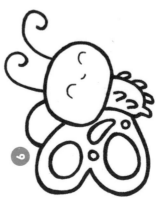

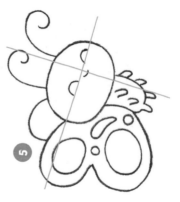

Spider ☆

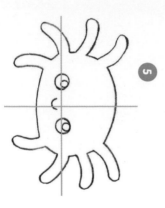

1

5

2

6

3

7

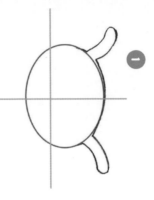

4

8

☆ Ladybird ☆

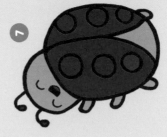

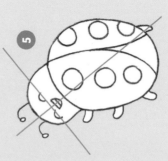

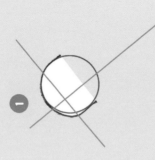

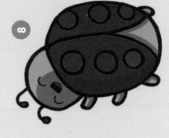

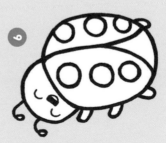

☆ Snail ☆

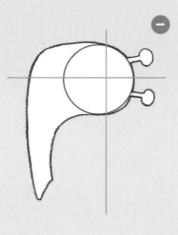

1

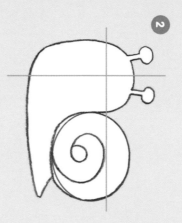

2

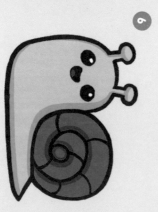

3

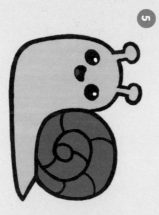

4

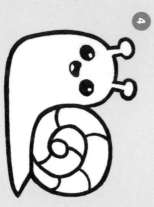

5

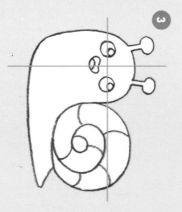

6

☆ Shell ☆

4

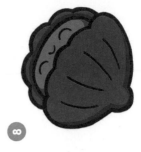

8

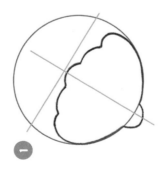

3

7

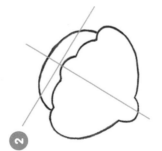

2

6

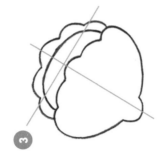

1

5

Crab ☆

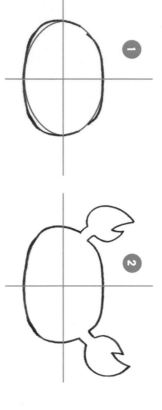

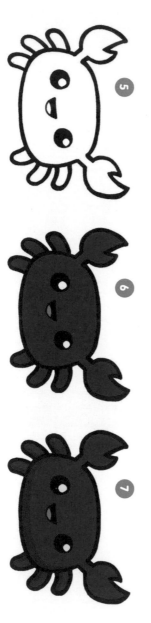

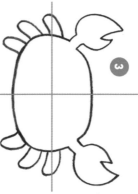

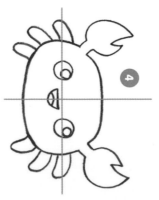

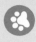

☆ Tortoise ☆

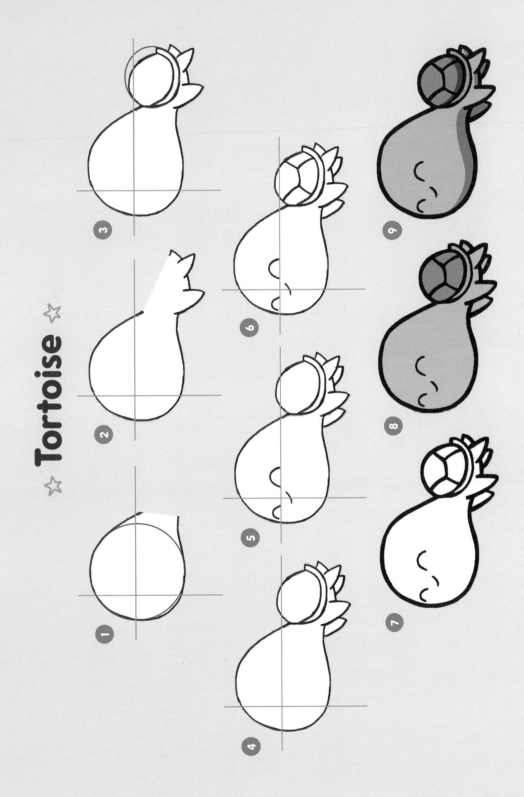

☆ **Puffer Fish** ☆

☆ Goldfish ☆

4

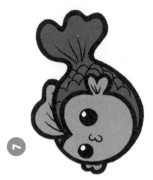

8

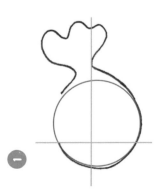

3

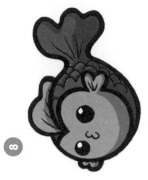

7

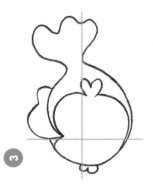

2

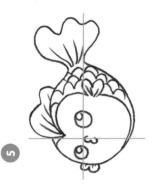

6

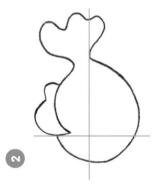

1

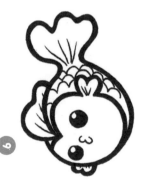

5

Squid

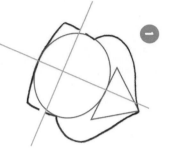

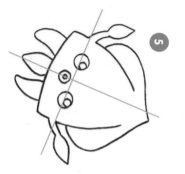

☆ Octopus ☆

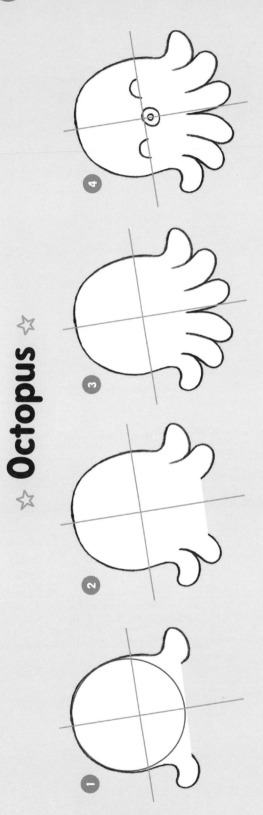

☆ Jellyfish ☆

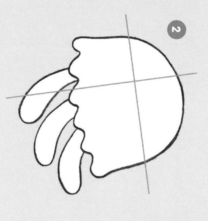

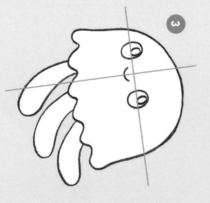

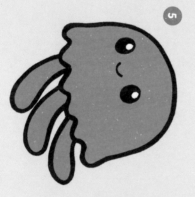

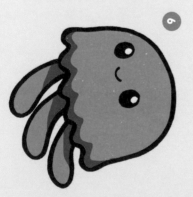

Seahorse

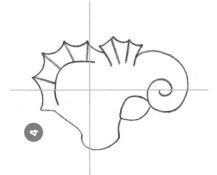

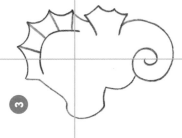

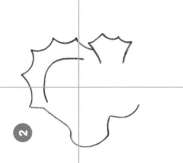

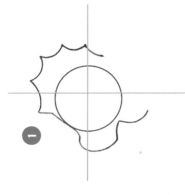

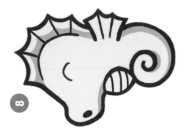

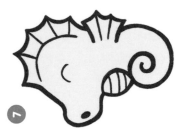

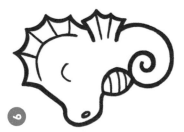

Whale

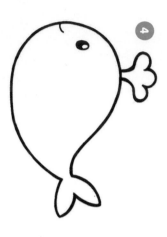

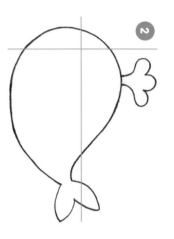

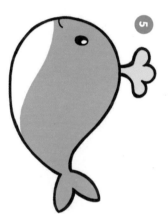

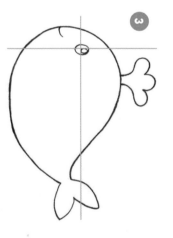

☆ Ray ☆

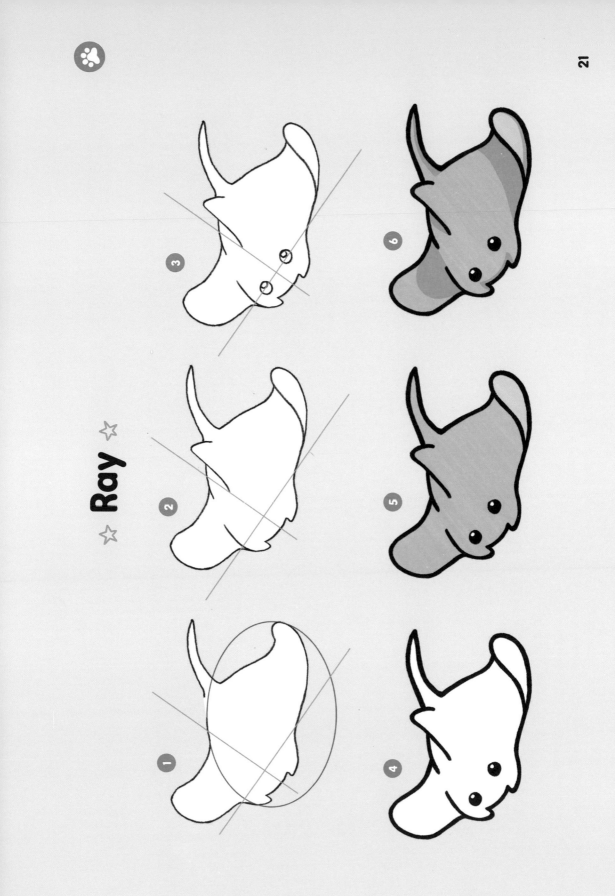

☆ Shark ☆

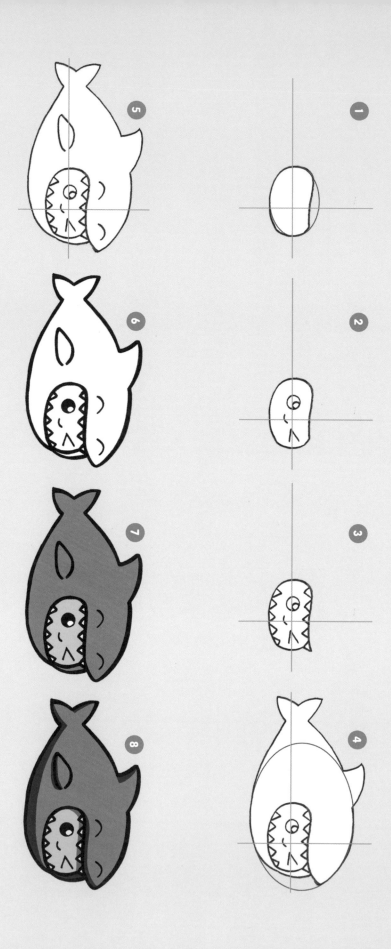

Orca

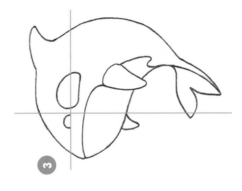

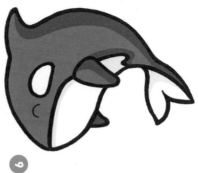

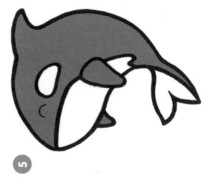

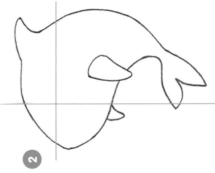

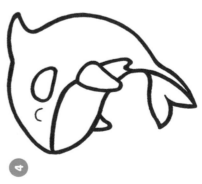

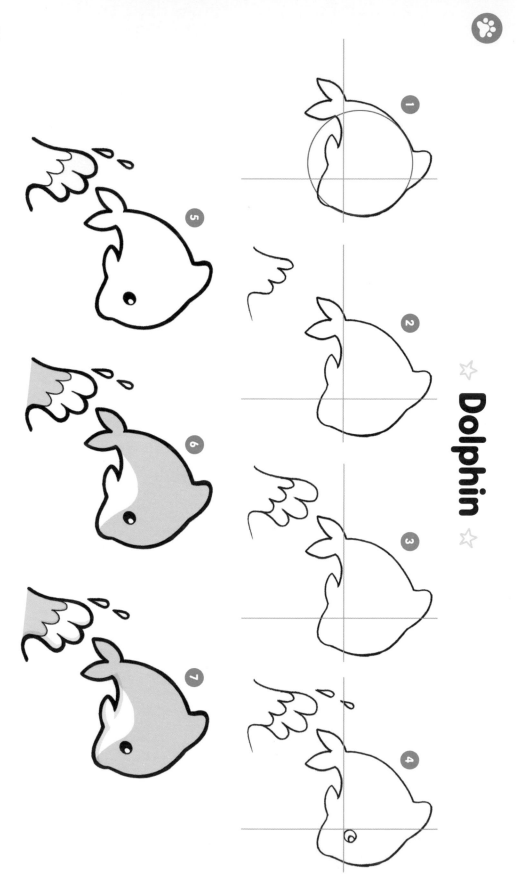

Dolphin ☆ ☆

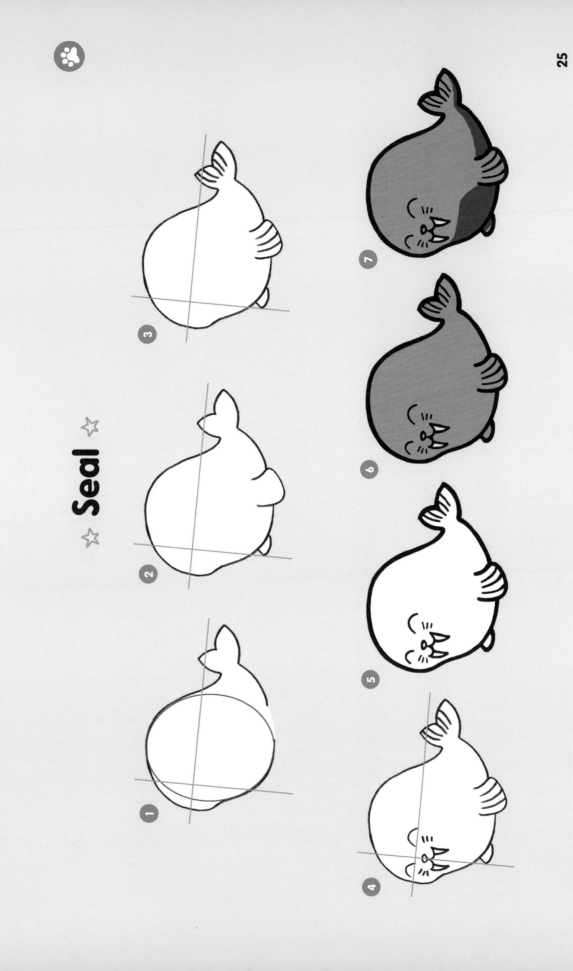

☆ Seal ☆

Penguin

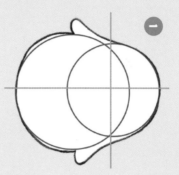

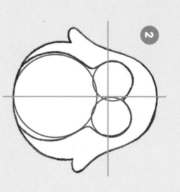

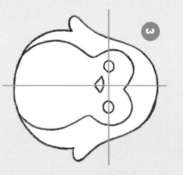

Flamingo ☆ ☆

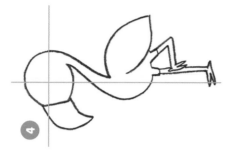
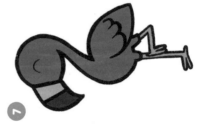
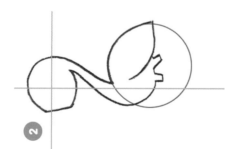
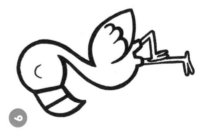

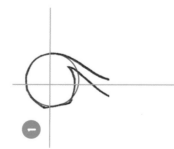

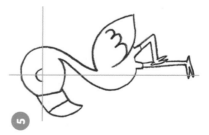

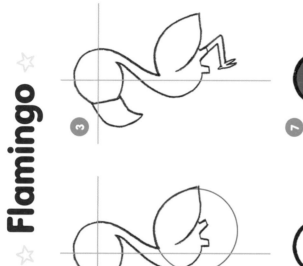

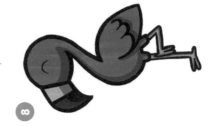

Ostrich

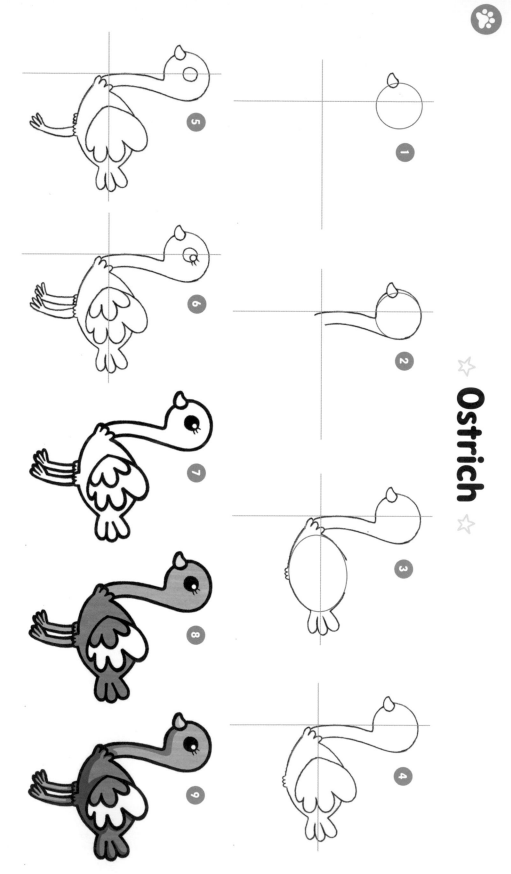

☆ Peacock ☆

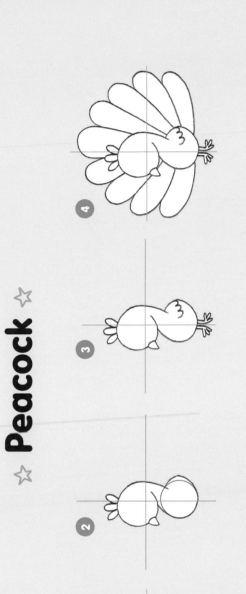

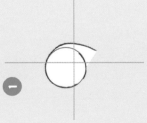

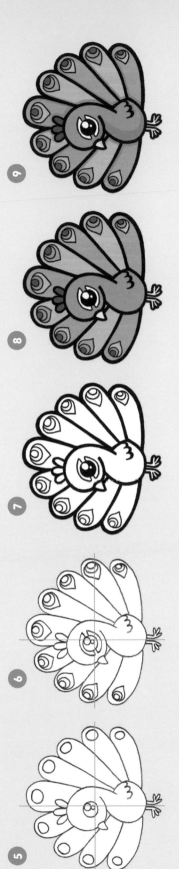

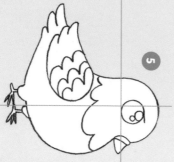

☆ Pigeon ☆

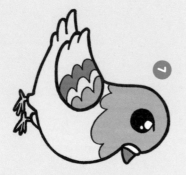

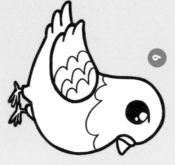

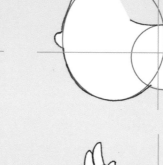

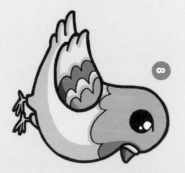

Swan ☆

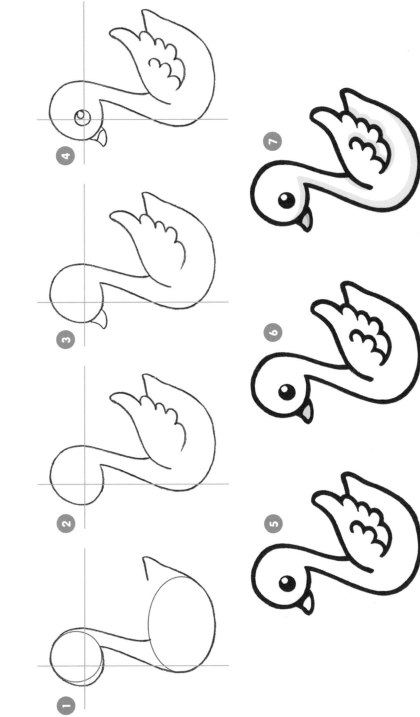

Owl

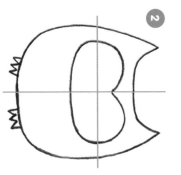

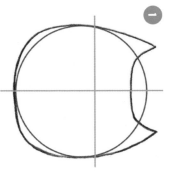

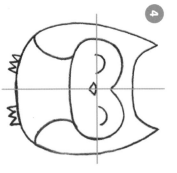

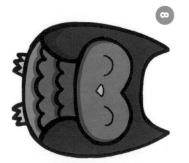

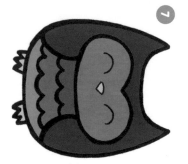

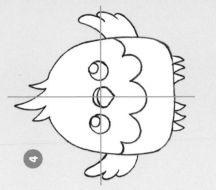
4

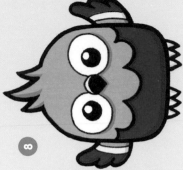
8

☆ Parrot ☆

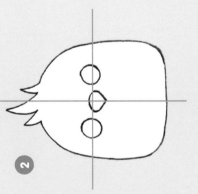
3

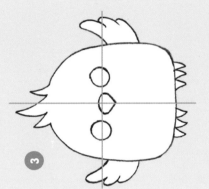
7

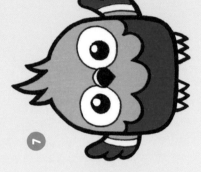
2

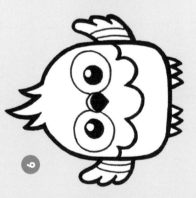
6

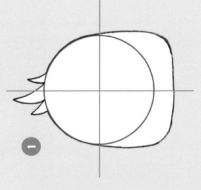
1

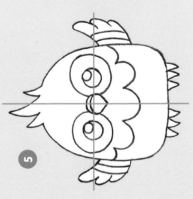
5

Feather

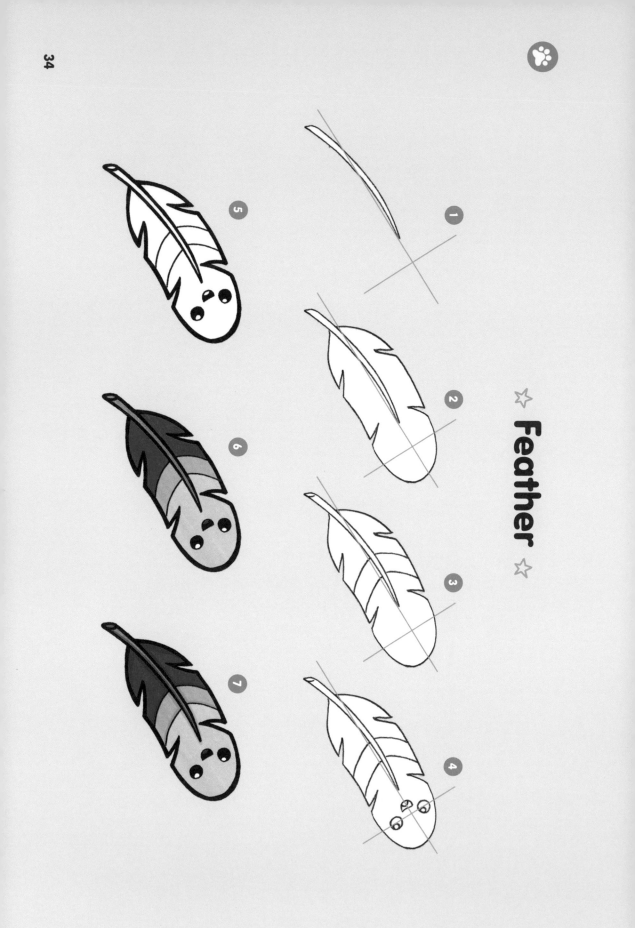

☆ Robin ☆

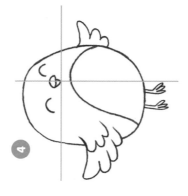

1

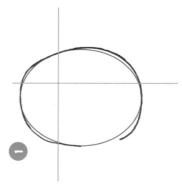

2

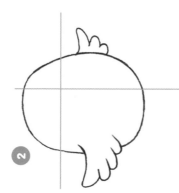

3

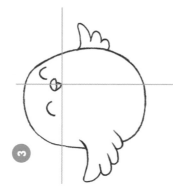

4

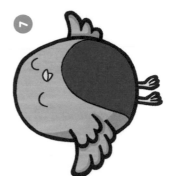

5

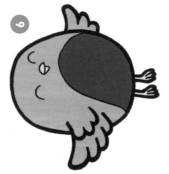

6

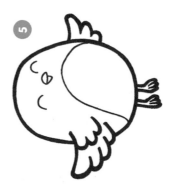

7

Chick

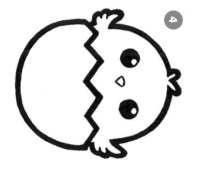

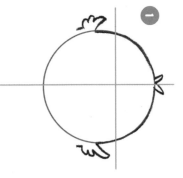

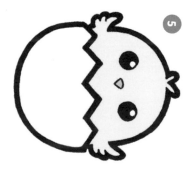

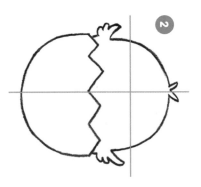

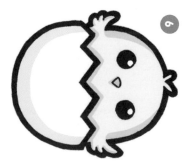

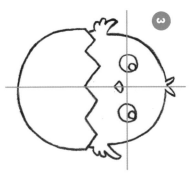

☆ Mouse ☆

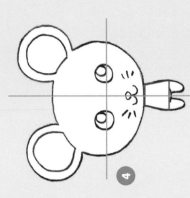

2

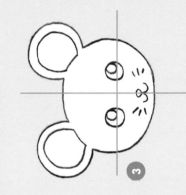

4

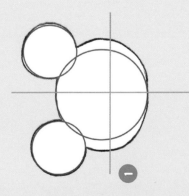

3

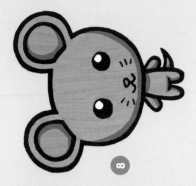

8

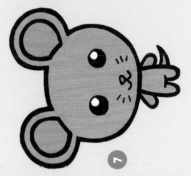

1

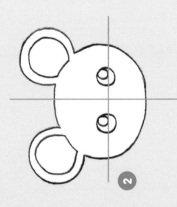

6

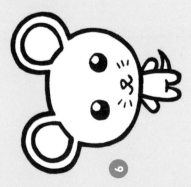

5

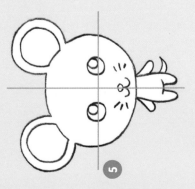

7

☆ **Hamster** ☆

1

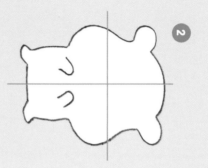

2

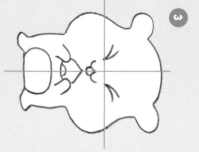

3

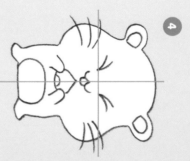

4

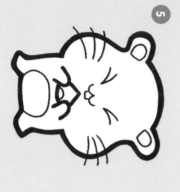

5

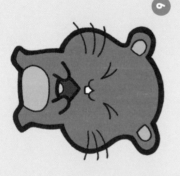

6

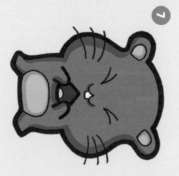

7

Rabbit

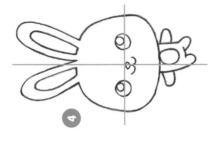

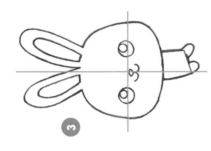

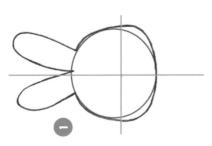

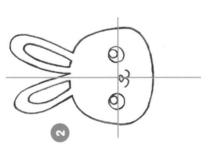

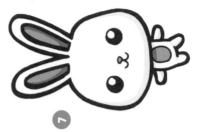

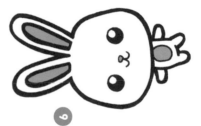

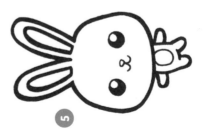

Ginger Cat

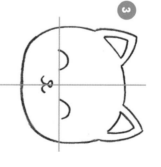

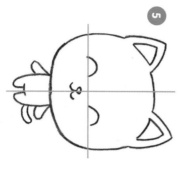

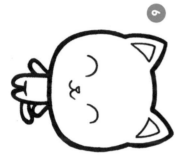

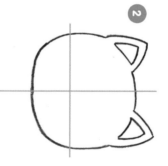

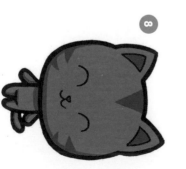

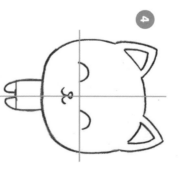

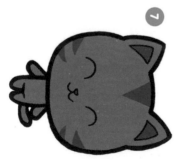

☆ Black Cat ☆

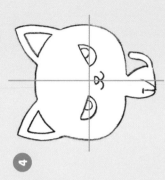

1

2

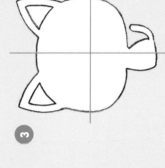

3

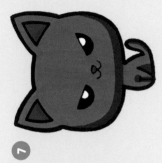

4

5

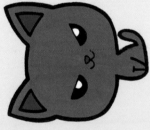

6

7

☆ Grey Cat ☆

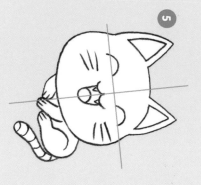

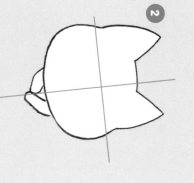

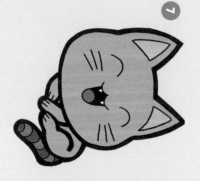

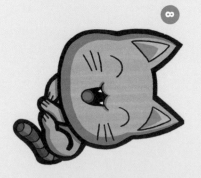

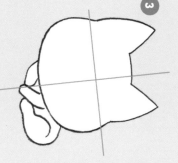

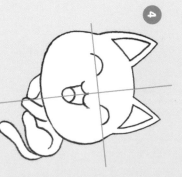

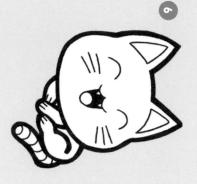

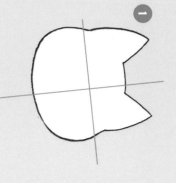

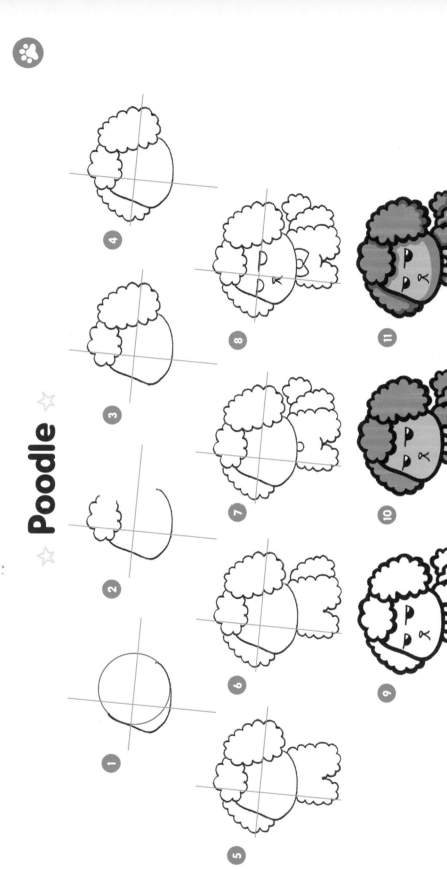

Poodle

Dog

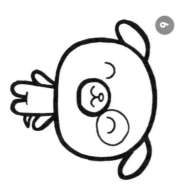

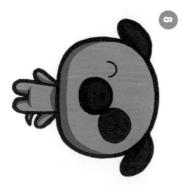

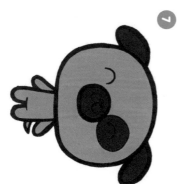

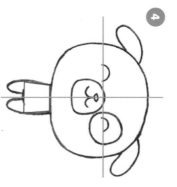

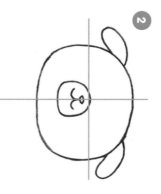

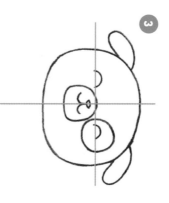

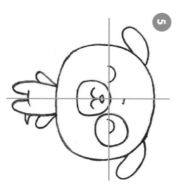

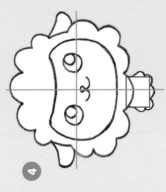

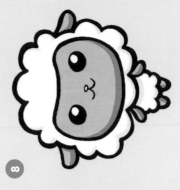

☆ Sheep ☆

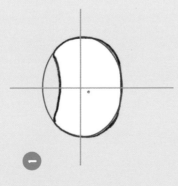

3

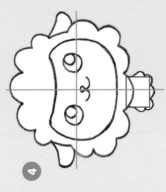

7

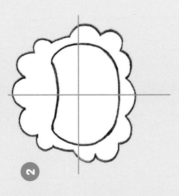

2

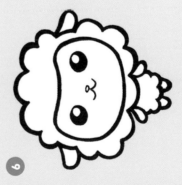

6

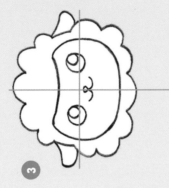

1

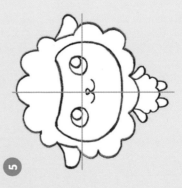

5

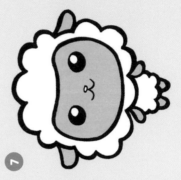

4

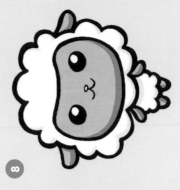

8

46

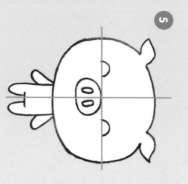

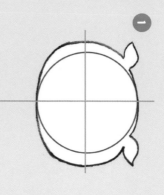

Pig

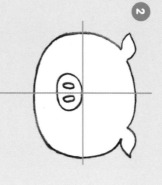

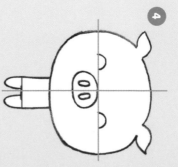

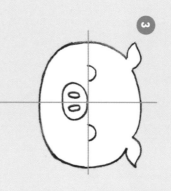

Cow ☆

☆

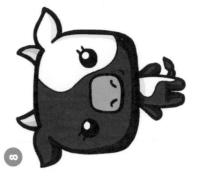

8

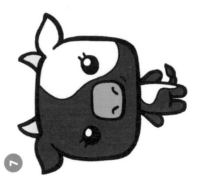

7

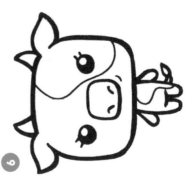

6

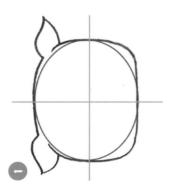

5

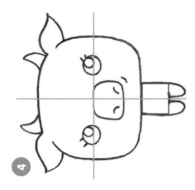

4

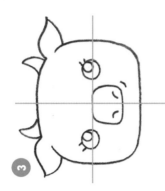

3

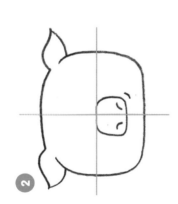

2

1

Elephant ☆ ☆

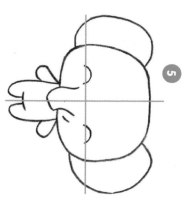

1

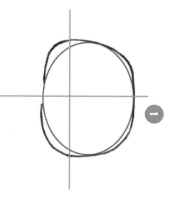

2

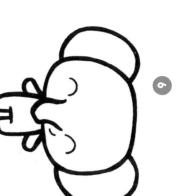

3

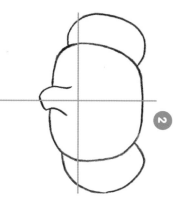

4

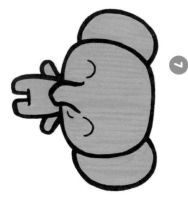

5

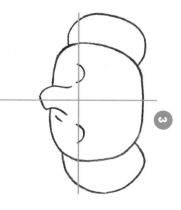

6

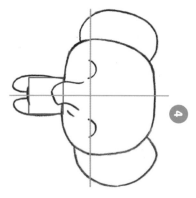

7

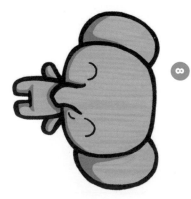

8

☆ Hippopotamus ☆

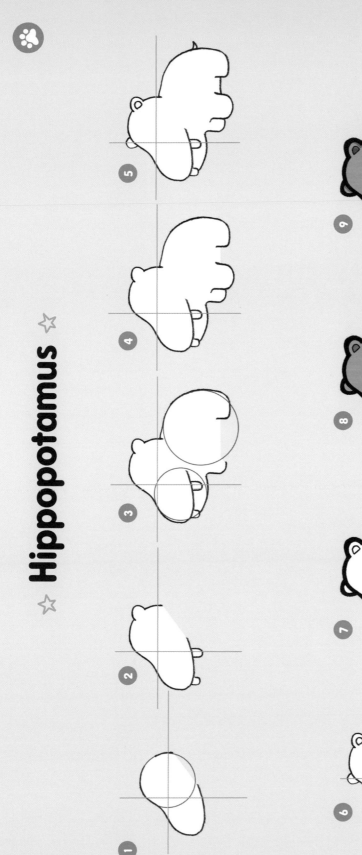

Giraffe

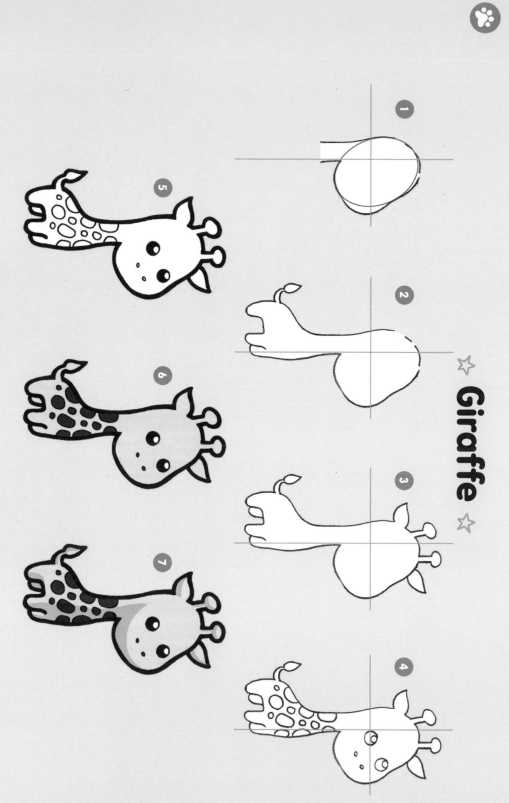

☆ Lion ☆

3

4

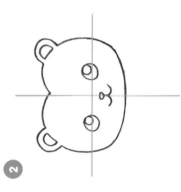

7

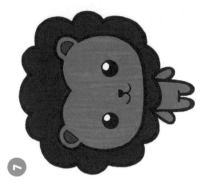

8

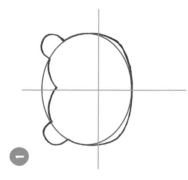

2

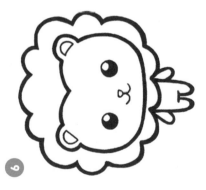

6

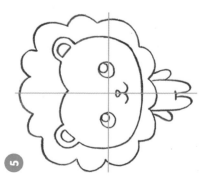

1

5

Camel

☆ ☆

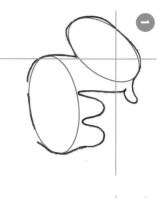

1

2

3

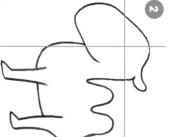

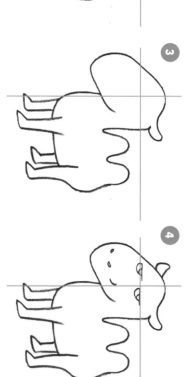

4

5

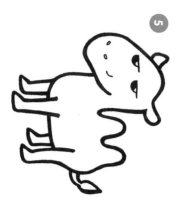

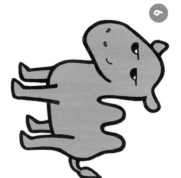

6

7

☆ Zebra ☆

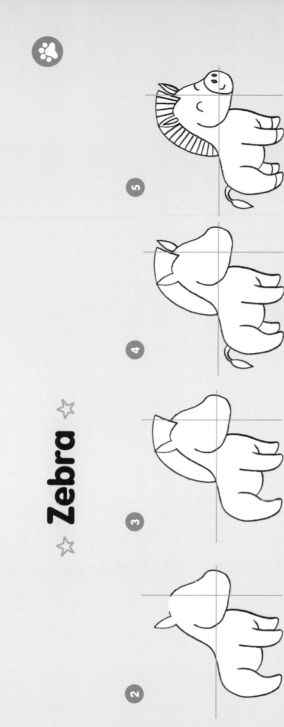

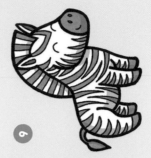

☆ Unicorn ☆

1

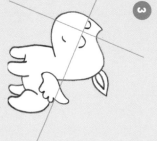

2

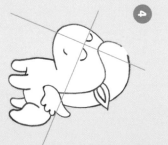

3

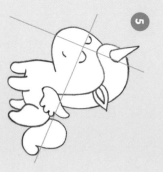

4

5

6

7

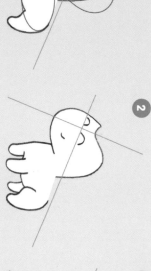

8

9

Dragon ☆ ☆

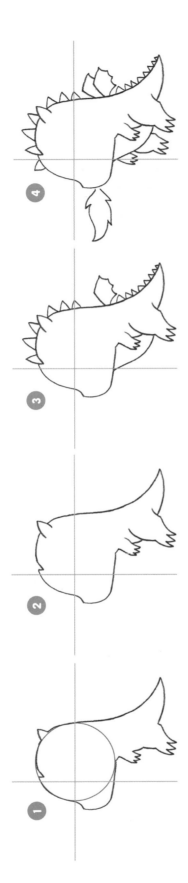

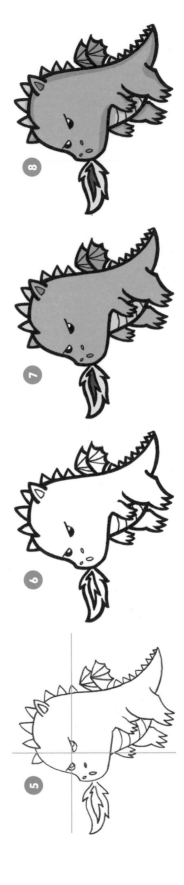

Dinosaur

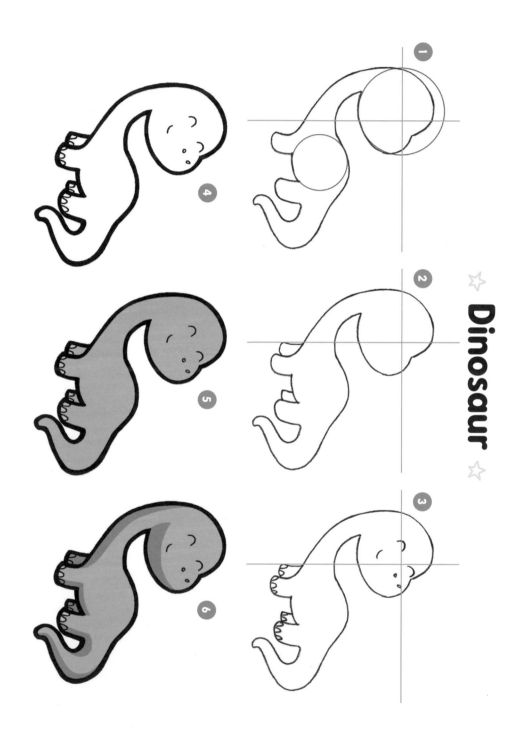

☆ Snake ☆

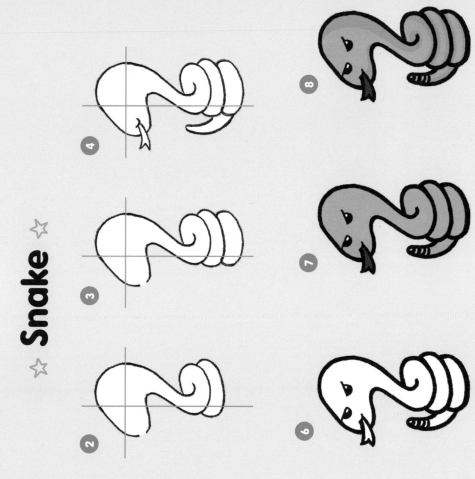

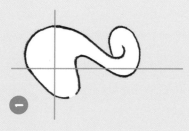

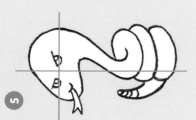

Gorilla

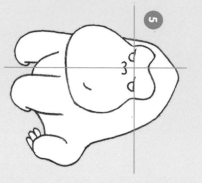

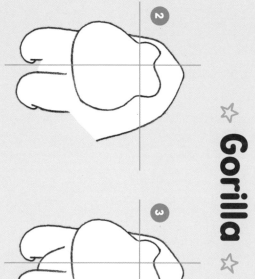

☆ Monkey ☆

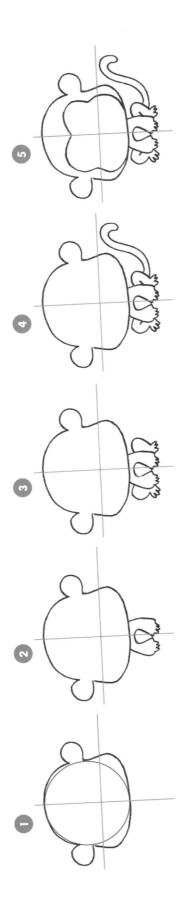

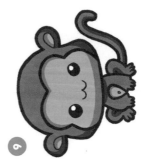

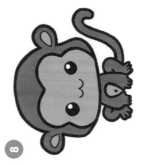

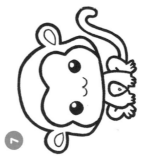

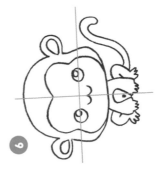

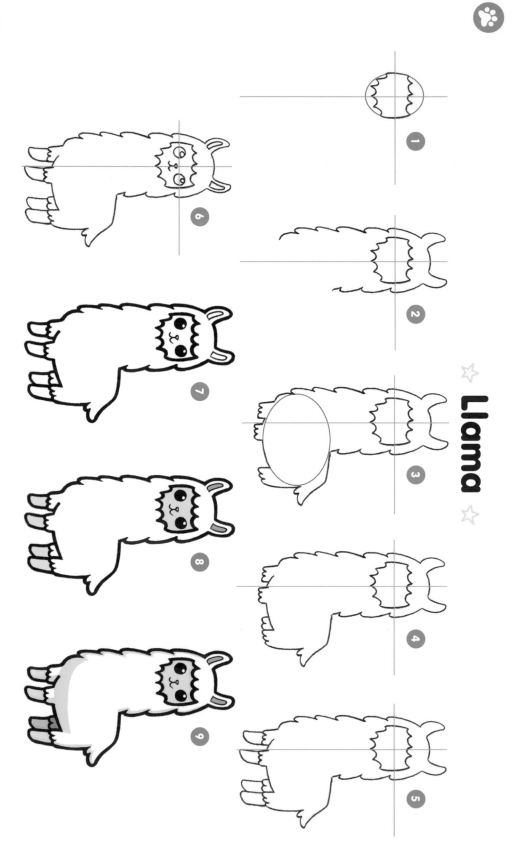

Llama

☆ Koala ☆

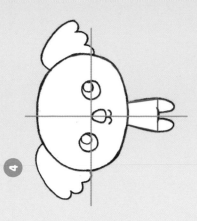

1

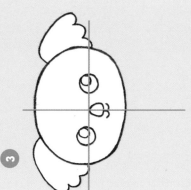

2

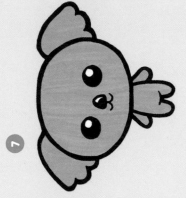

3

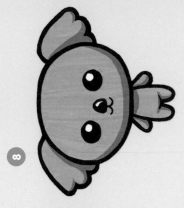

4

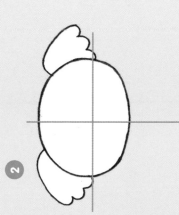

5

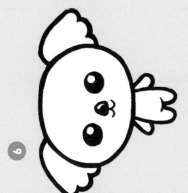

6

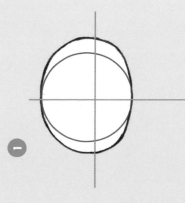

7

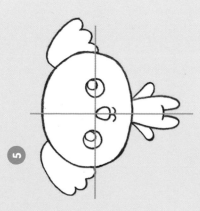

8

Red Panda

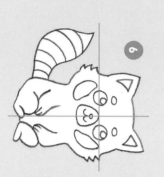

1

2

3

4

5

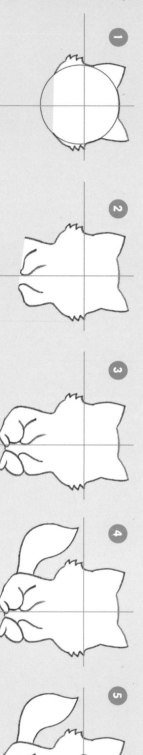

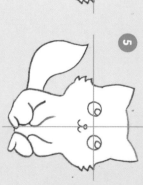

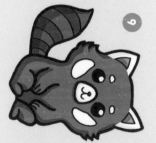

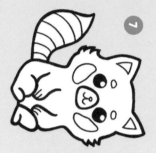

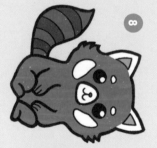

6

7

8

9

☆ Panda ☆

1

2

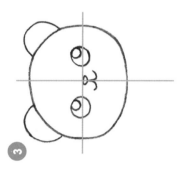

3

4

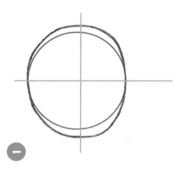

5

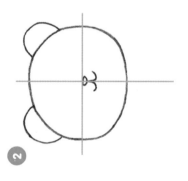

6

7

8

Polar Bear

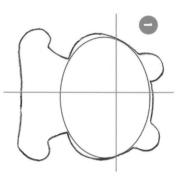

1

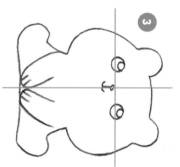

2

3

4

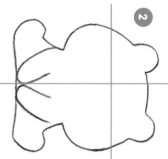

5

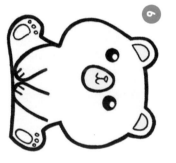

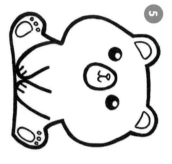

6

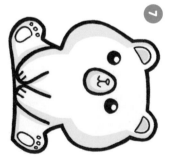

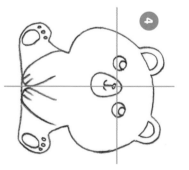

7

☆ Skunk ☆

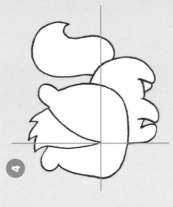

2

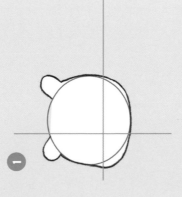

1

3

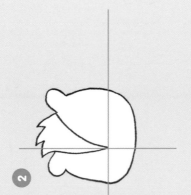

4

6

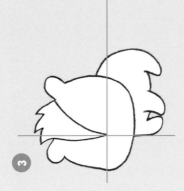

5

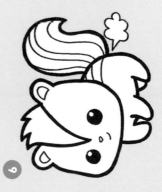

8

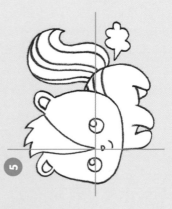

7

{}

Beaver

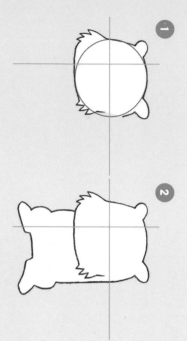

1

2

3

4

5

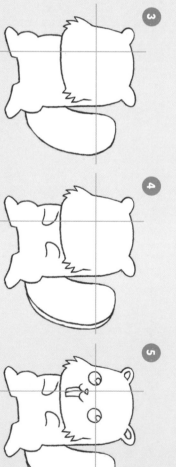

6

7

8

9

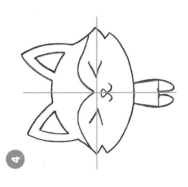

Fox

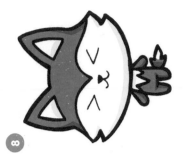

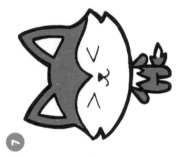

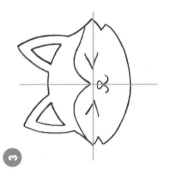

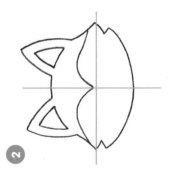

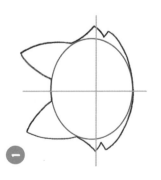

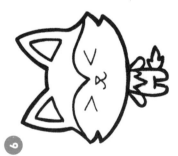

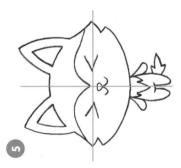

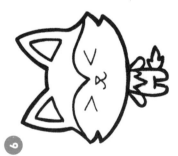

67

☆ **Doe** ☆

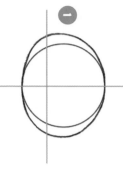

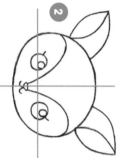

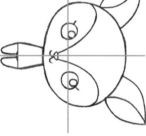

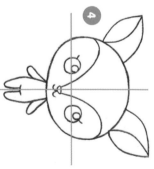

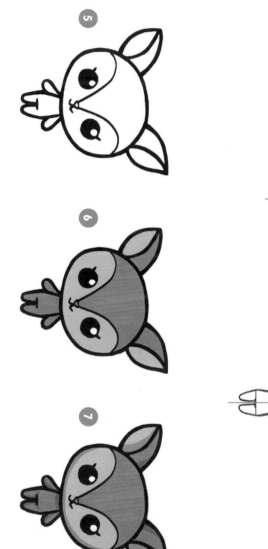

 Reindeer ☆

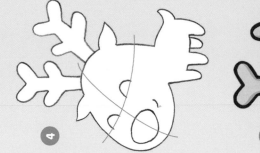

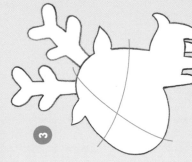

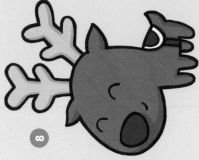

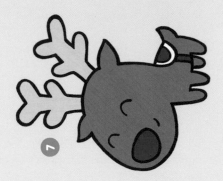

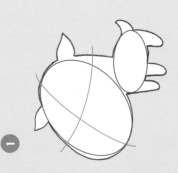

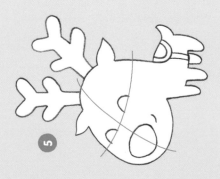

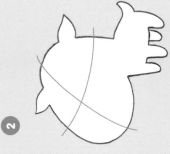

☆ Wolf ☆

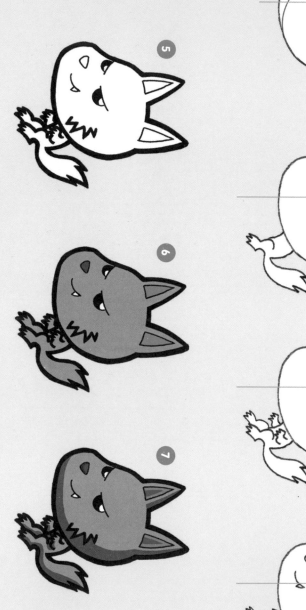
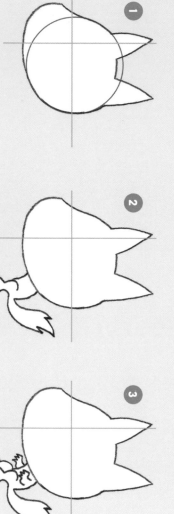
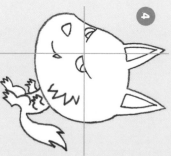

Bat

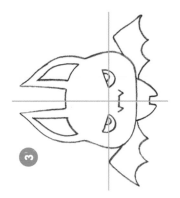

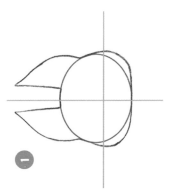

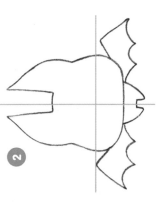

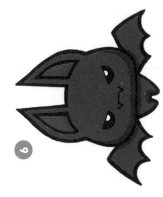

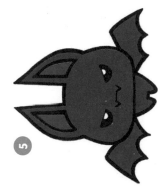

Squirrel

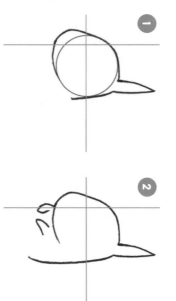

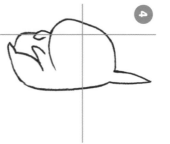

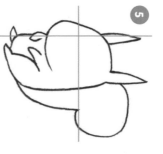

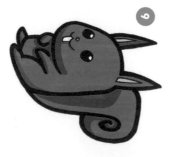

☆ Hedgehog ☆

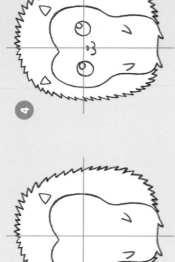

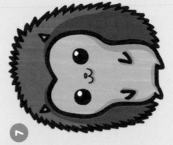

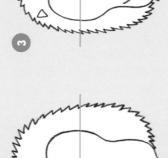

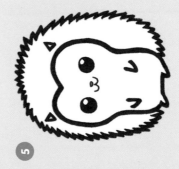

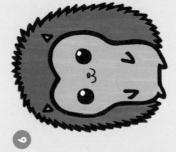

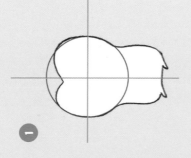

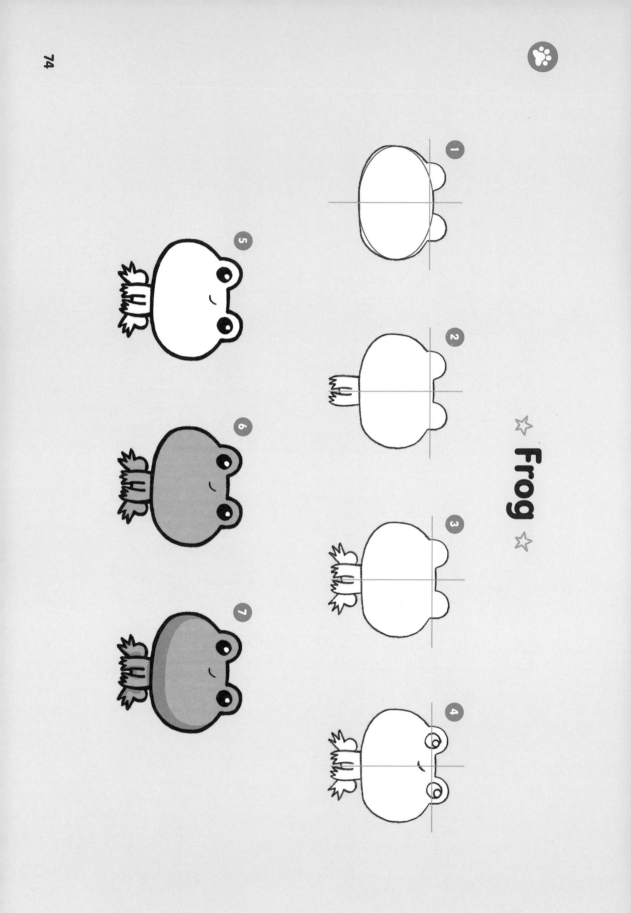

Frog

☆ Lily Pad and Flower ☆

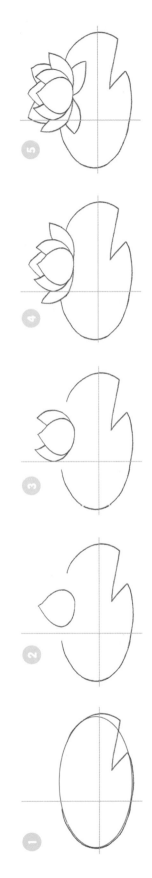

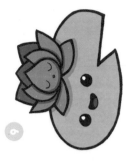

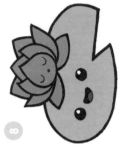

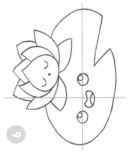

Rose

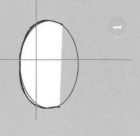

1

2

3

4

5

6

7

8

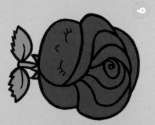

9

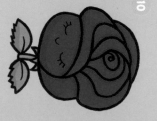

10

☆ Tulip ☆

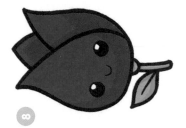

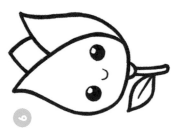

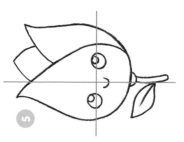

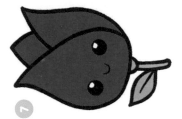

☆ Sunflower ☆

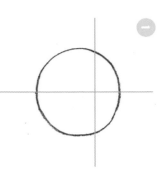

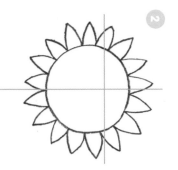

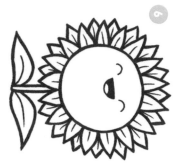

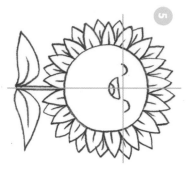

Daisy

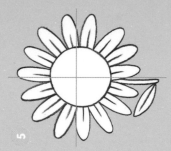

5

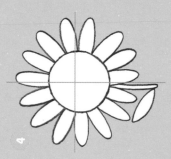

4

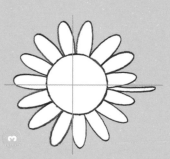

3

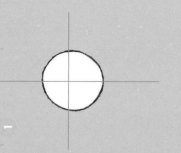

2

1

9

8

7

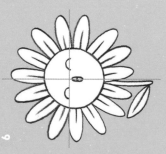

6

Little Cactus

1

2

☆ Big Cactus ☆

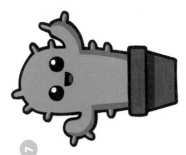

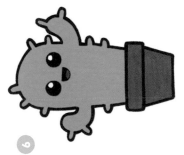

☆ Aloe Vera ☆

Bonsaï

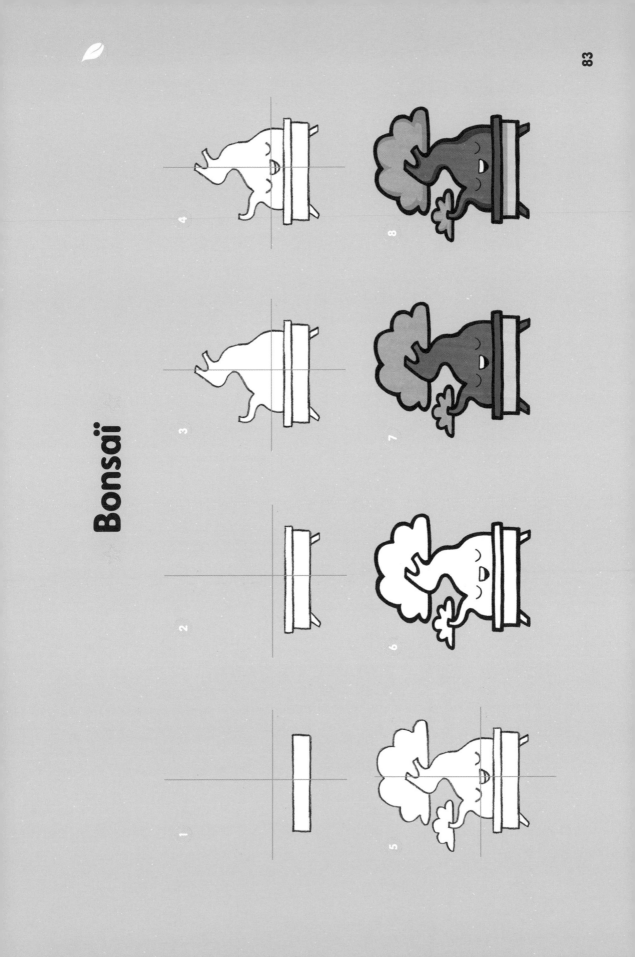

84

Shamrock

1

2

3

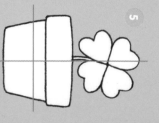

4

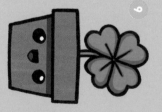

5

6

7

8

9

☆ Dandelion ☆

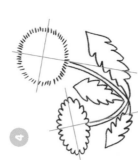

4

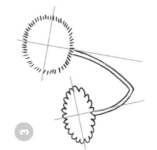

3

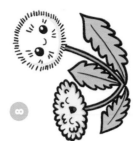

2

1

8

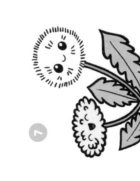

7

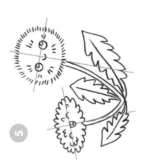

6

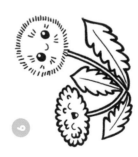

5

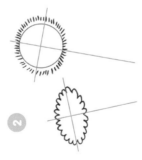

Lily of the Valley ☆

1

2

3

4

5

6

7

8

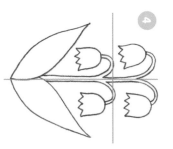

Holly

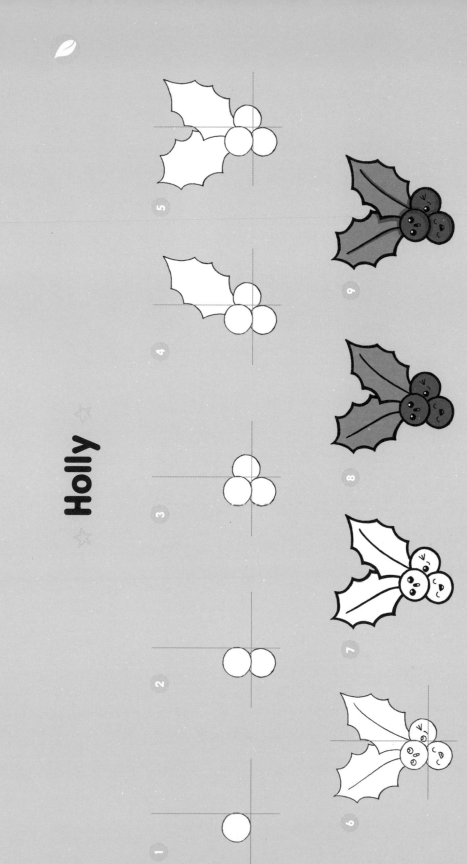

Log

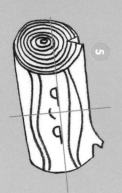

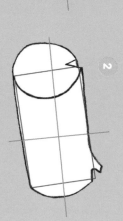

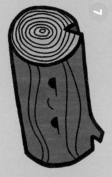

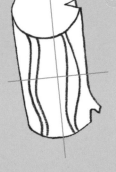

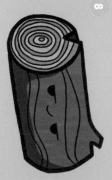

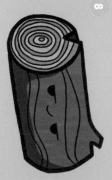

☆ Leaf ☆

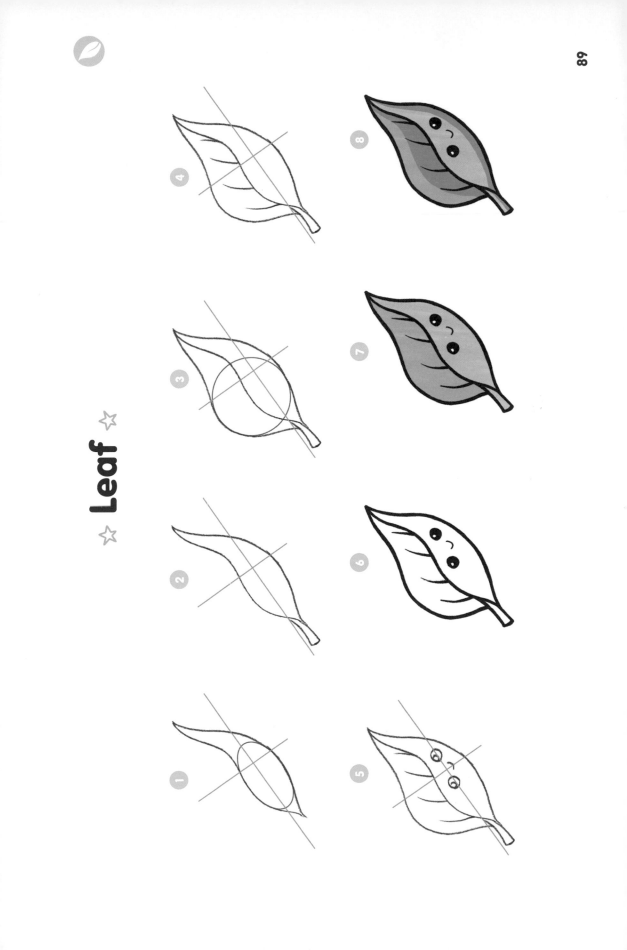

Acorn ☆

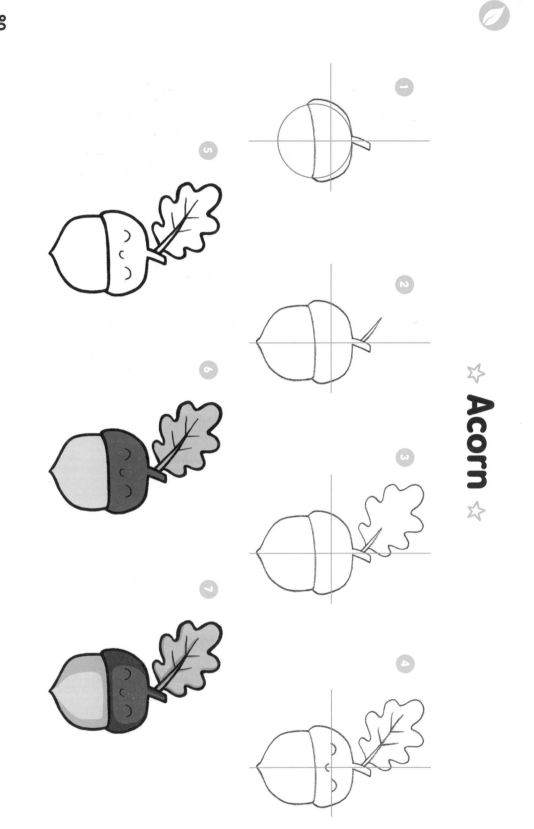

Mushroom

1
2
3
4
5
6
7

91

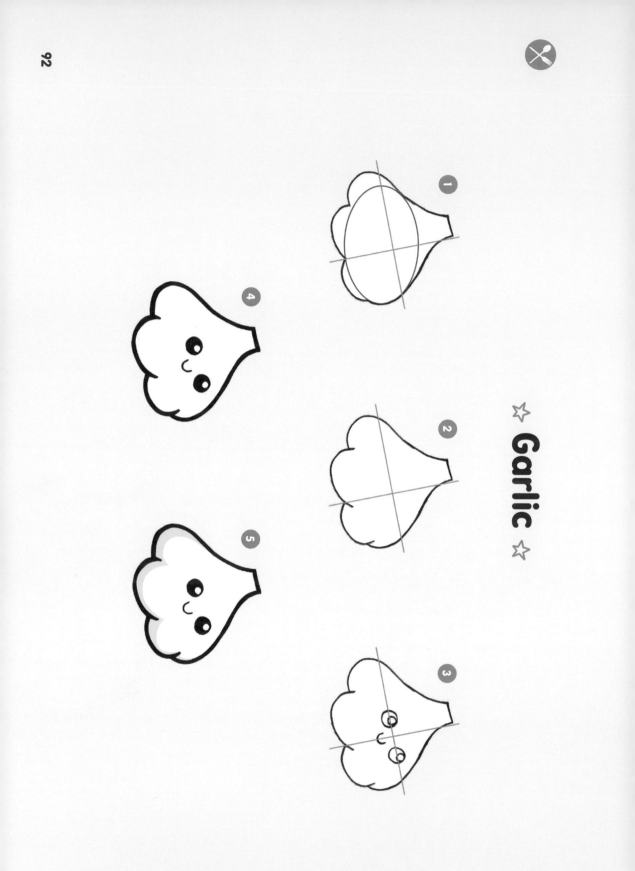

Garlic

Onion

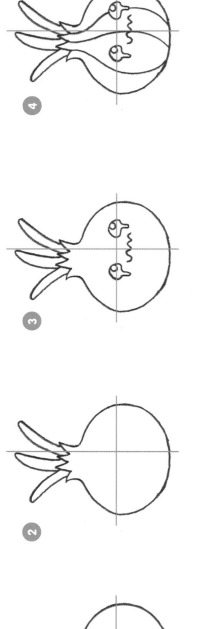

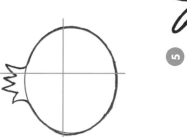

Chili

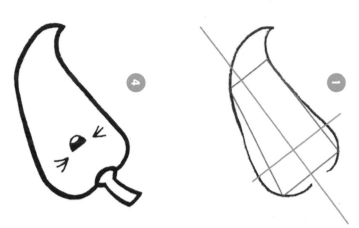

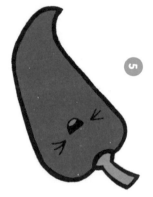

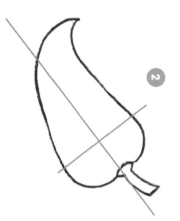

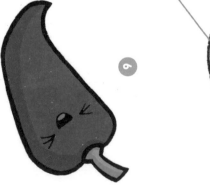

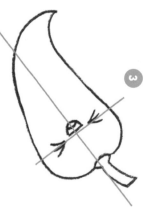

☆ Corn on the Cob ☆

4

3

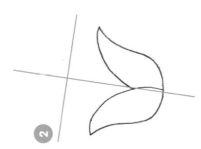

2

8

7

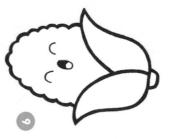

6

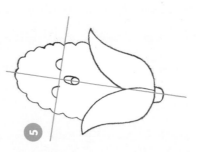

5

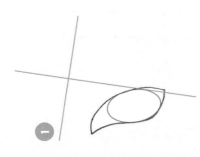

1

4

1

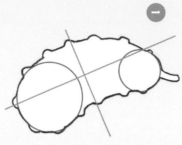

5

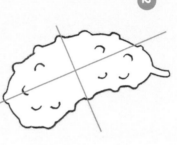

2

☆ Pickle ☆

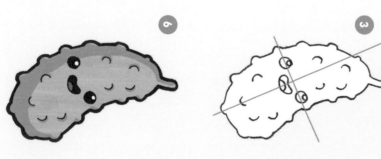

6

3

Radish

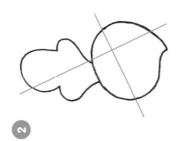

3

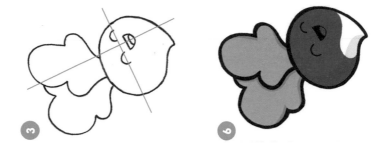

6

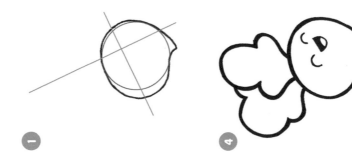

2

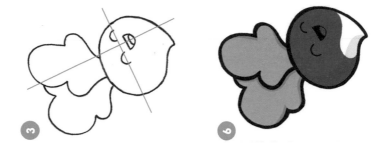

5

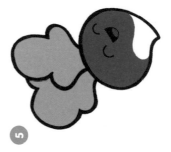

1

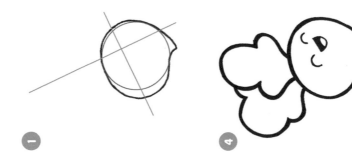

4

Beetroot

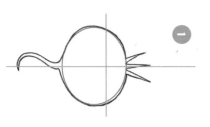

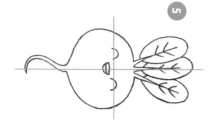

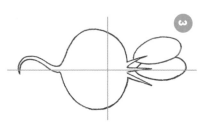

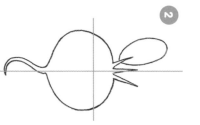

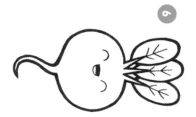

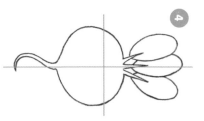

☆ Lettuce ☆

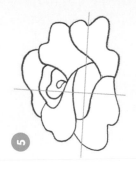

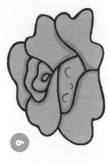

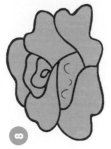

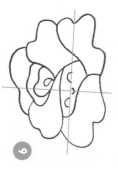

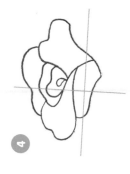

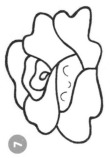

☆ Cauliflower ☆

1

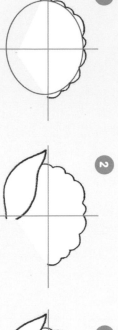

2

3

4

5

6

7

8

9

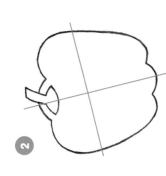

3

6

Bell Pepper

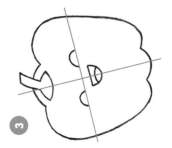

2

5

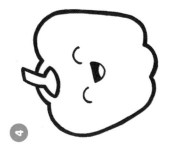

1

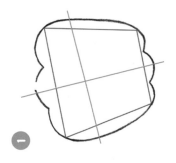

4

Broccoli

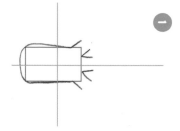

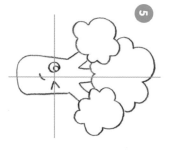

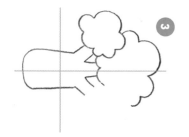

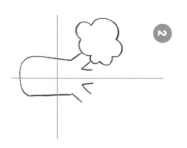

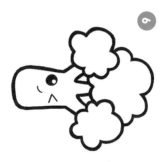

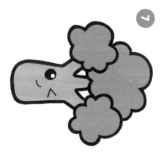

☆ **Leek** ☆

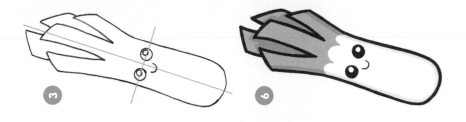

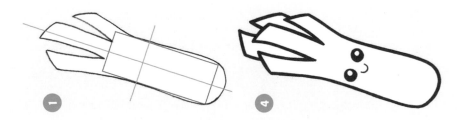

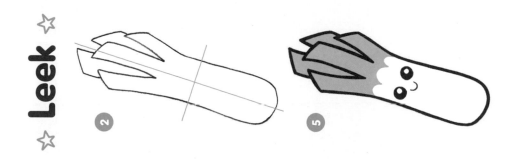

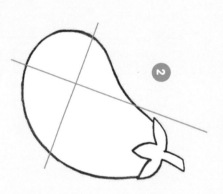

1

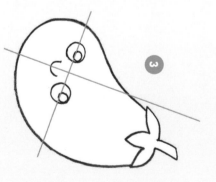

2

3

4

5

6

☆ **Aubergine** ☆

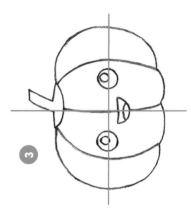

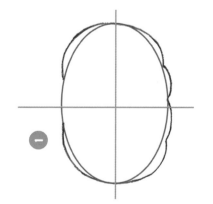

Pumpkin

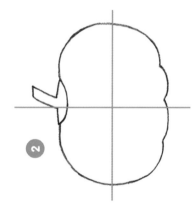

Carrot

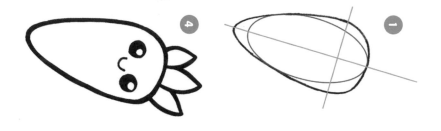

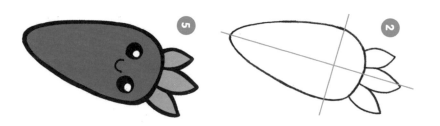

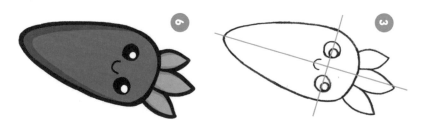

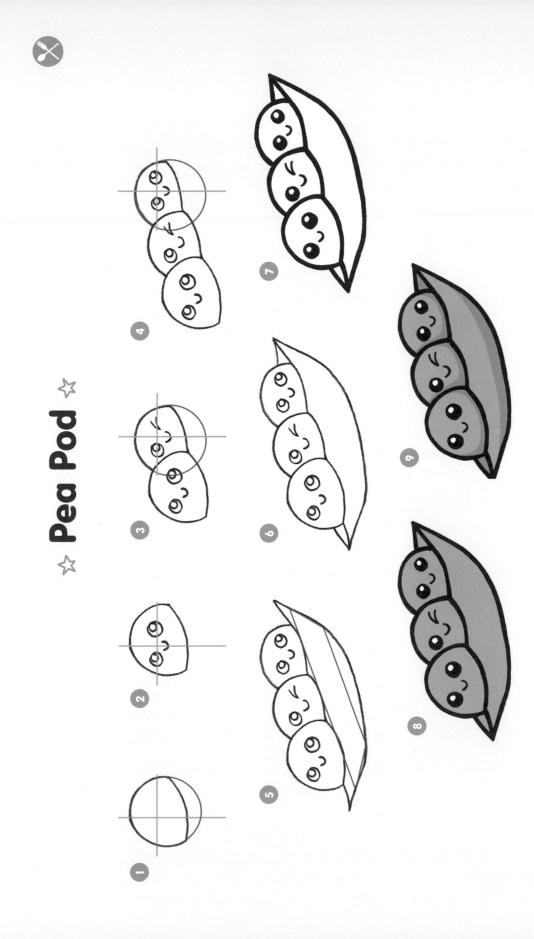

☆ Pea Pod ☆

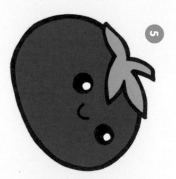

4

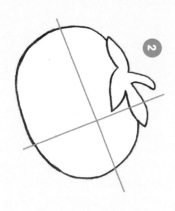

1

☆ **Tomato** ☆

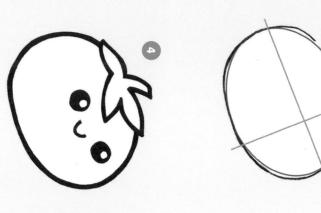

2

5

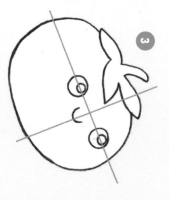

6

3

Ravioli

1

2

3

4

5

6

7

Swiss Cheese

1

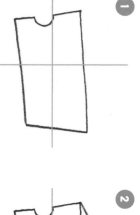

2

3

4

5

6

7

☆ Camembert ☆

4

7

6

2

1

8

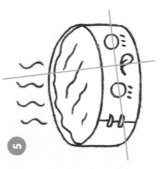

5

☆ Sandwich ☆

1

2

3

4

5

6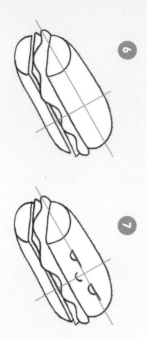

7

8

9

10

Baguette

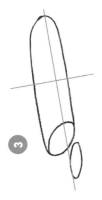

3

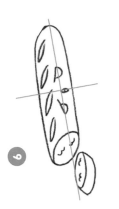

6

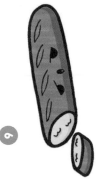

9

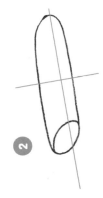

2

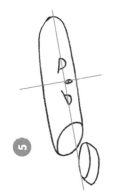

5

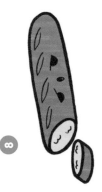

8

1

4

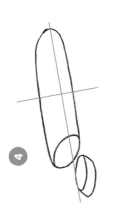

7

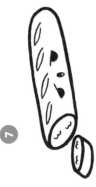

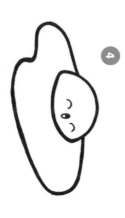

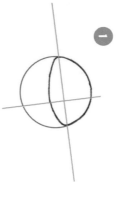

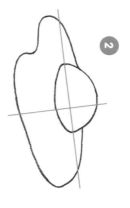

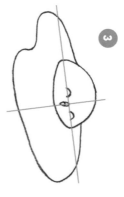

Fried Egg

☆ Boiled Egg ☆

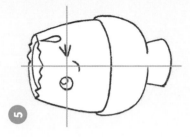

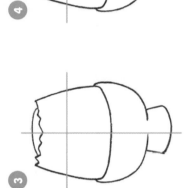

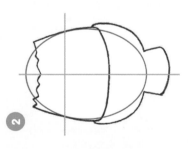

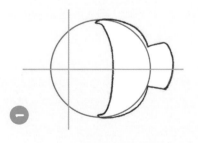

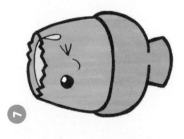

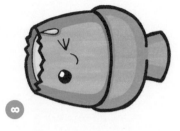

Chicken Leg

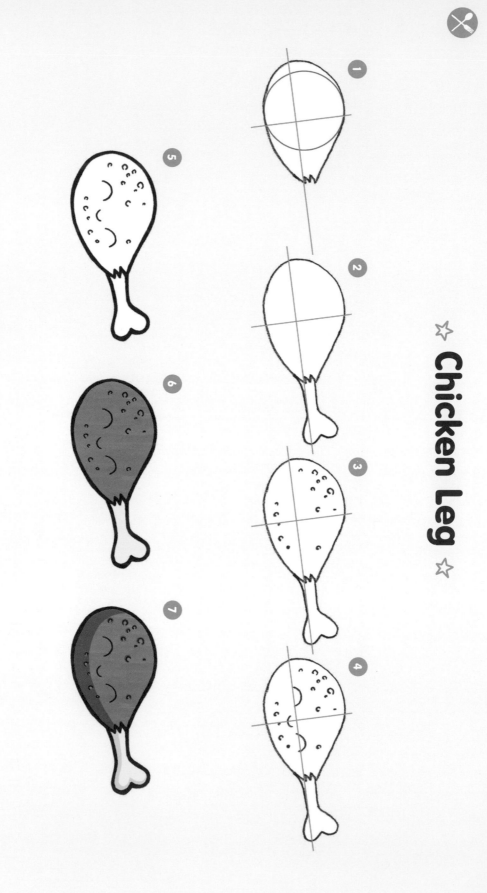

Steak

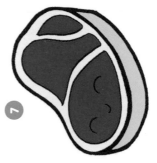

Hot Dog

1

5

2

6

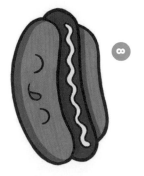

3

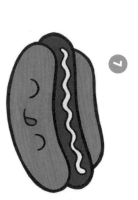

7

4

8

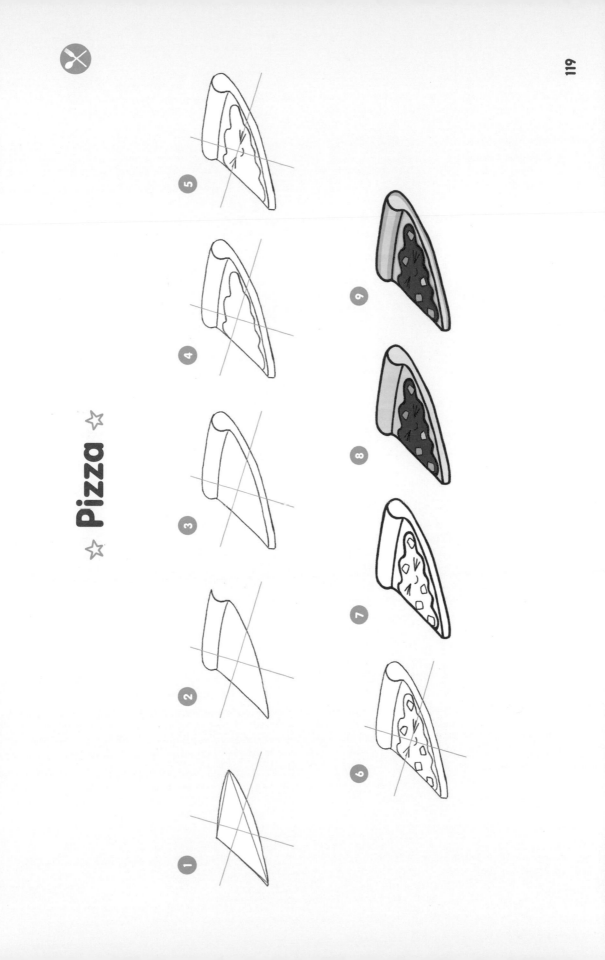

☆ Pizza ☆

Hamburger

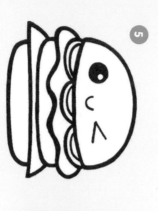

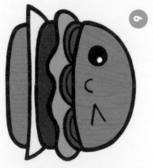

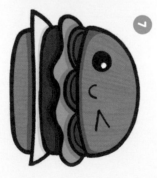

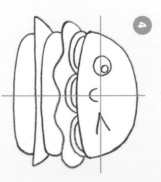

Fries

1

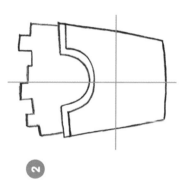

3

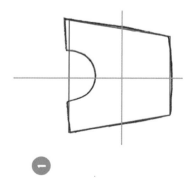

2

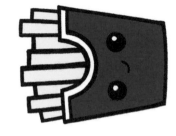

5

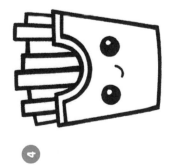

6

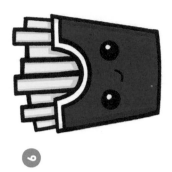

4

Salt and Pepper

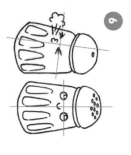

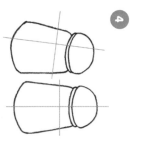

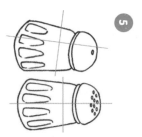

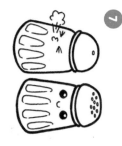

☆ Soup ☆

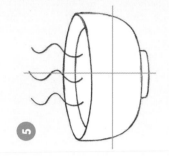

1

2

3

4

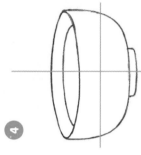

5

6

7

8

9

124

Onigiri

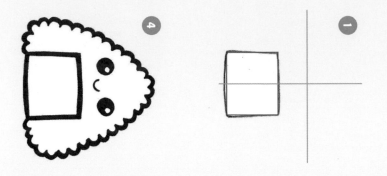

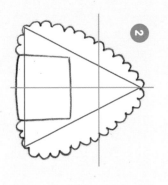

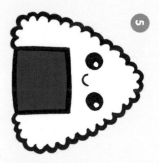

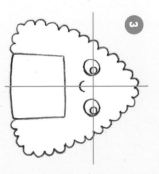

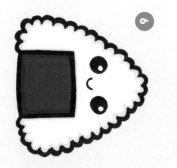

Sushi

1

2

3

4

5

6

7

5

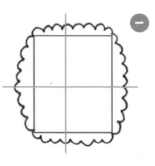
1

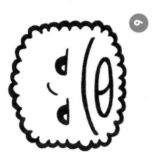
6

2

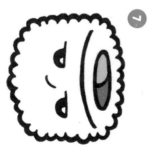
7

3

8

4

California Roll

126

☆ Maki ☆

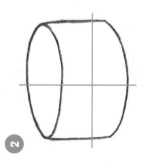

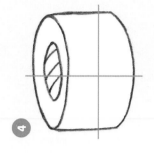

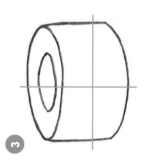

☆ Teabag ☆

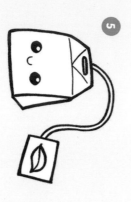

1

2

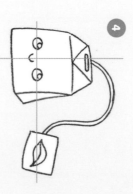

3

4

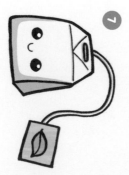

5

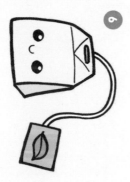

6

7

Cup of Tea

Teapot

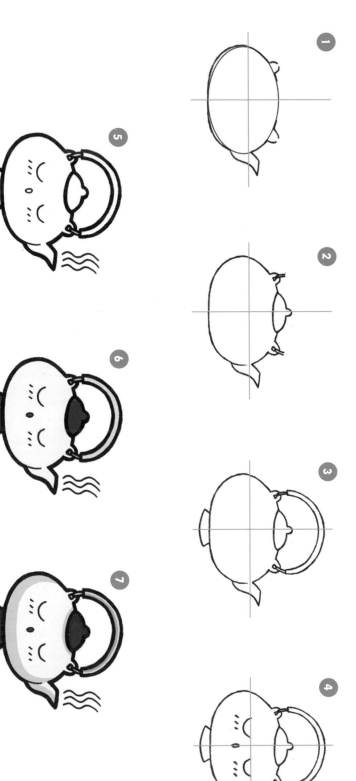

☆ Hot Chocolate ☆

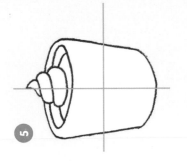

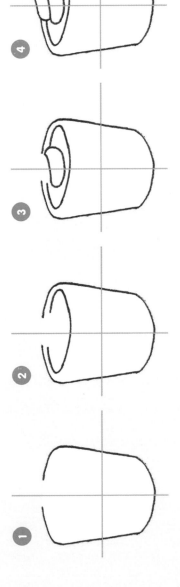

☆ Milk Carton ☆

1

2

3

4

5

6

7

8

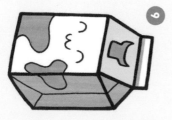

9

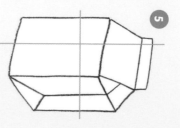

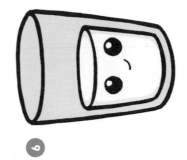
3

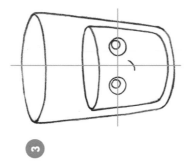
6

Glass of Milk

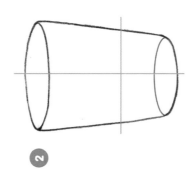
2

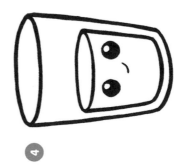
5

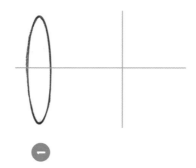
1

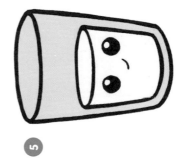
4

Baby Bottle

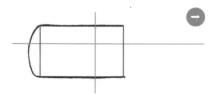

1

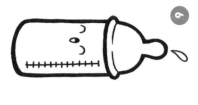

2

3

4

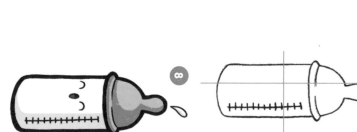

5

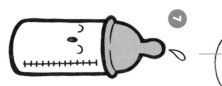

6

7

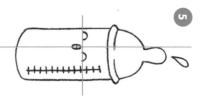

8

☆ Ice Cube ☆

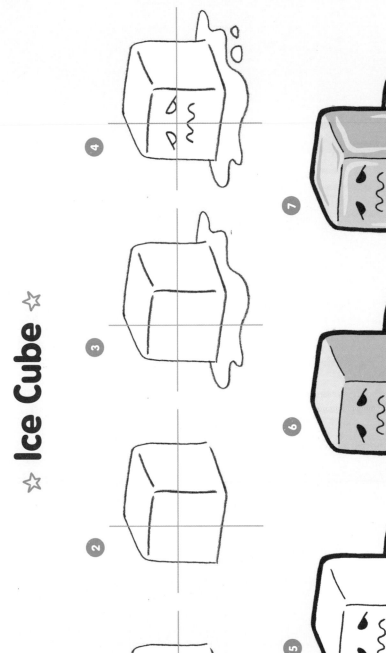

☆ Soda Cup ☆

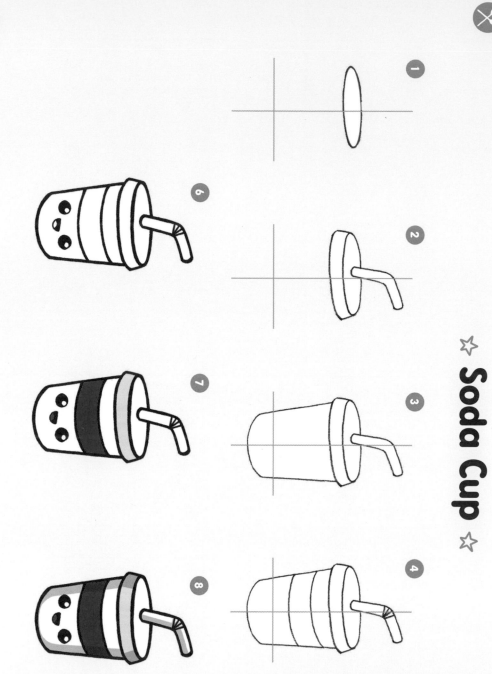

Soda Can

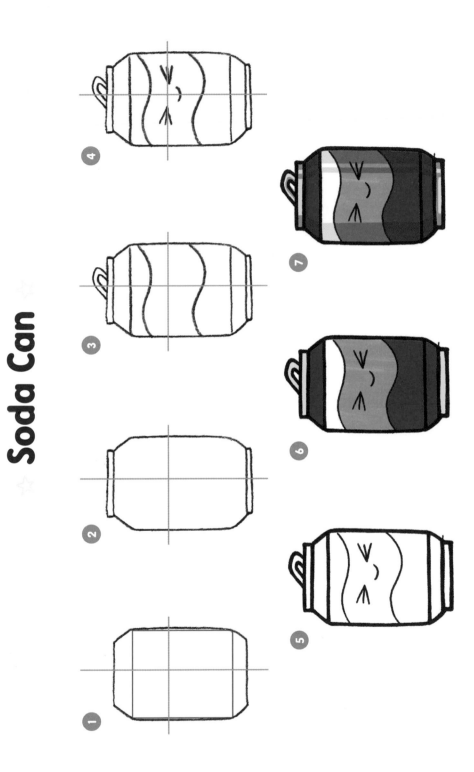

Cocktail

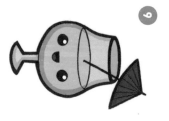

☆ Juice Carton ☆

1

2

3

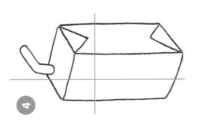
4

5

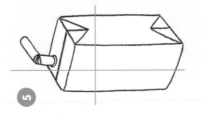
6

7

8

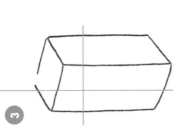
9

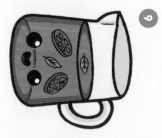

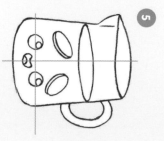

☆ Pitcher ☆

Clementine

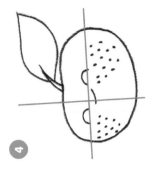

4

3

2

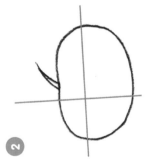

1

7

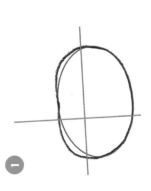

6

5

Lemon

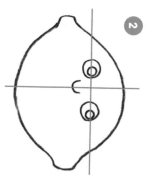

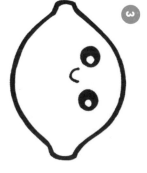

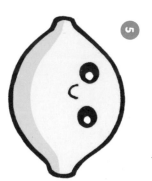

☆ Avocado ☆

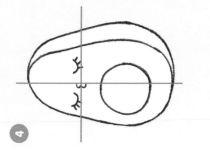

5

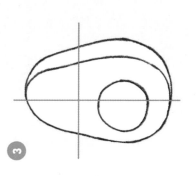

1

7

4

6

3

2

144

Grapefruit

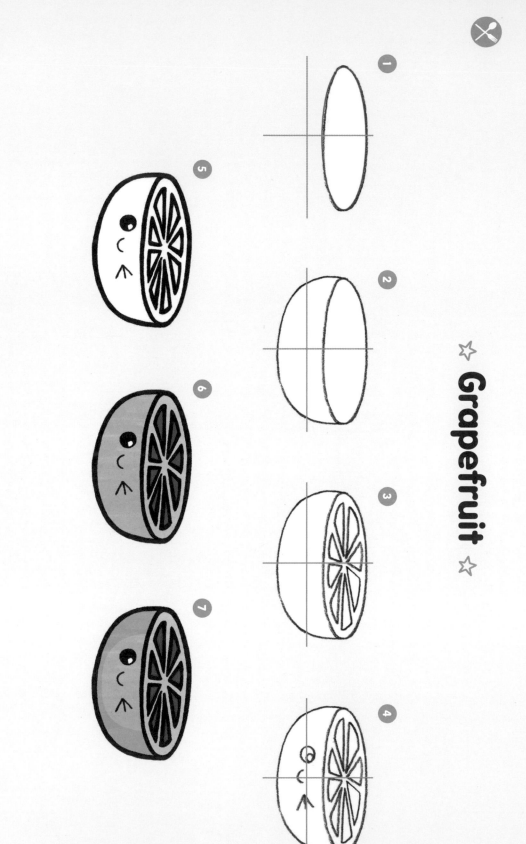

Pineapple

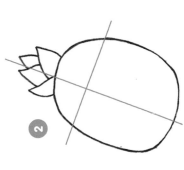

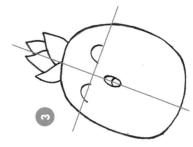

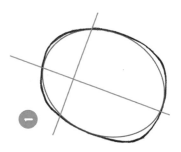

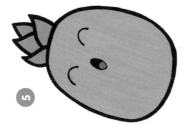

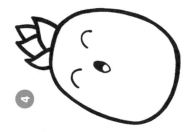

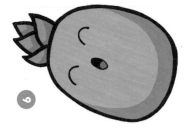

Watermelon

1

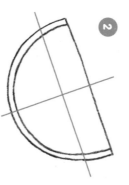

2

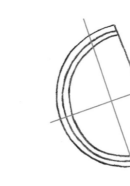

3

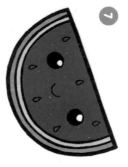

4

5

6

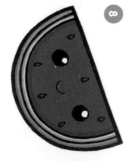

7

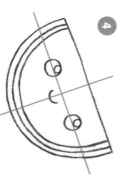

8

☆ Banana ☆

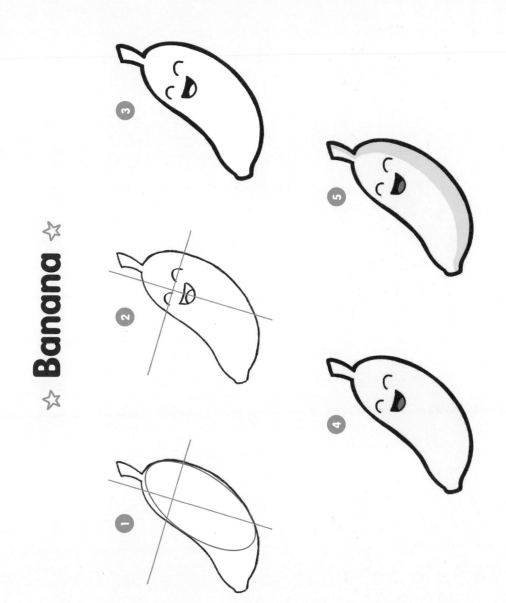

4

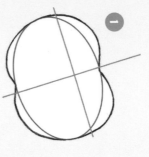

1

5

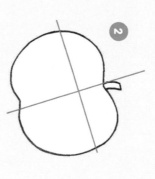

2

☆ Apple ☆

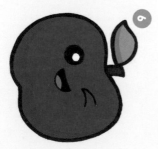

6

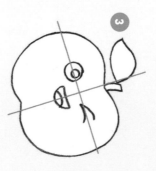

3

Pear

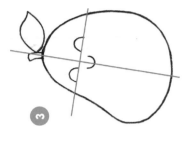

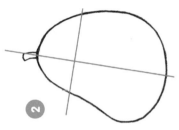

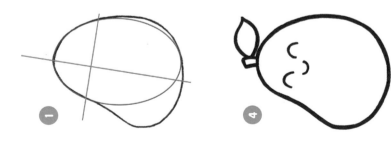

Cherries

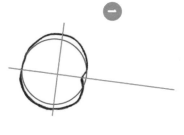

1

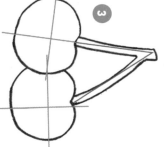

2

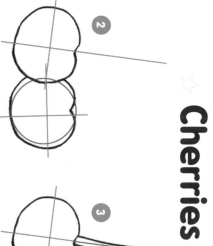

3

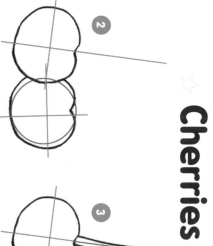

4

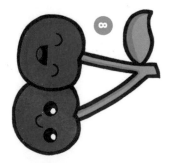

5

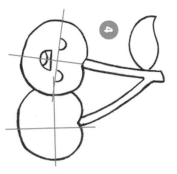

6

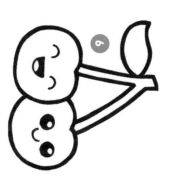

7

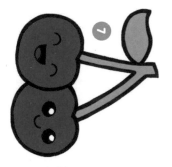

8

Raspberry ☆

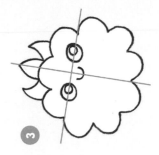
3

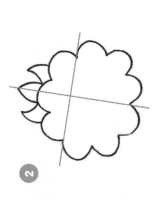
2

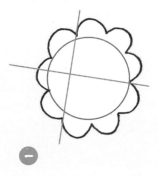
1

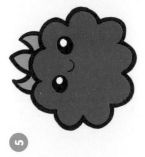
6

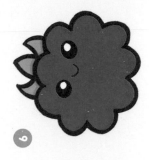
5

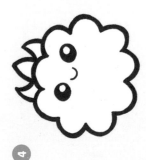
4

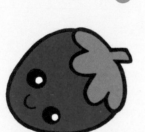

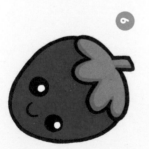

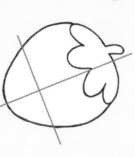

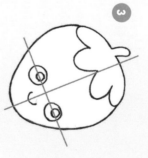

☆ **Strawberry** ☆

Yoghurt

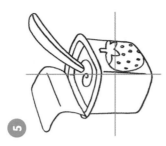

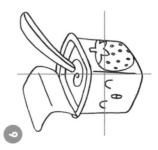

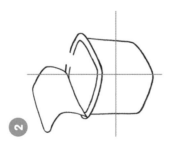

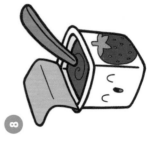

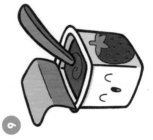

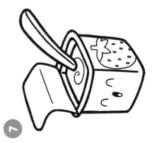

Jam Jar

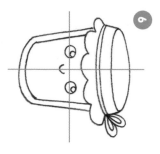

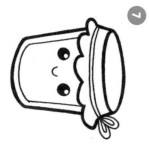

☆ Toast and Jam ☆

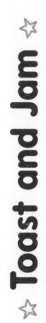

1

2

3

4

5

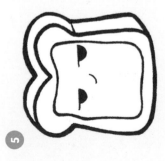

6

7

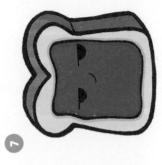

Chocolate Spread ☆

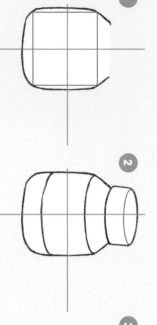

1

2

3

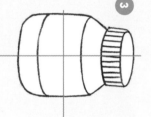

4

5

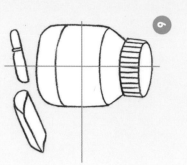

6

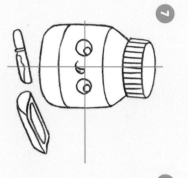

7

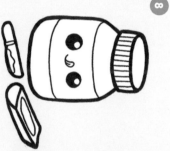

8

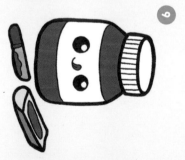

9

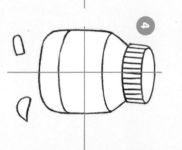

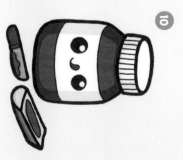

10

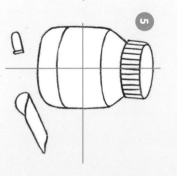

Chocolate Bar ☆

☆

1

2

3

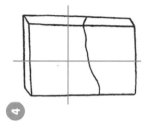

4

5

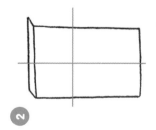

6

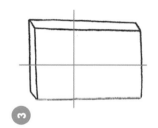

7

8

9

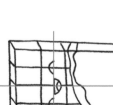

157

Muffin

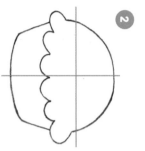
1

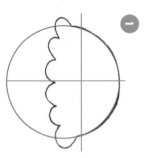
2

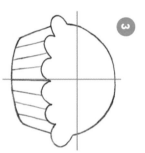
3

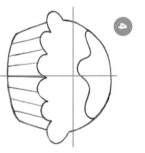
4

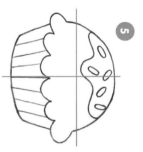
5

6

7

8

9

☆ Cupcake ☆

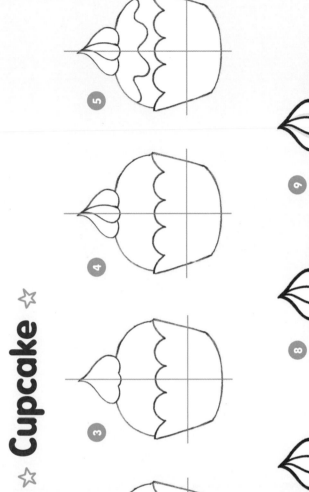

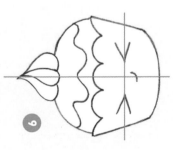

☆ Slice of Cake ☆

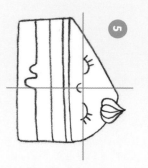

1

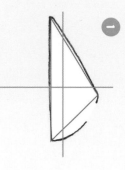

2

3

4

5

6

7

8

Rainbow Cake

1

2

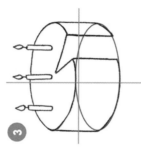

3

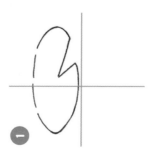

4

5

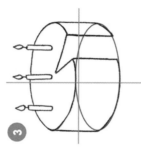

6

7

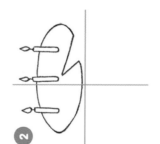

8

9

Christmas Pudding

☆ Gingerbread Man ☆

1

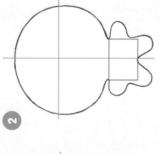
2

3

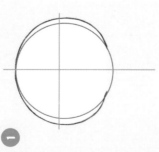

☆ Cookie ☆

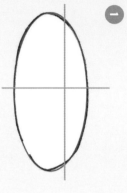

1

2

3

4

5

6

Pancakes

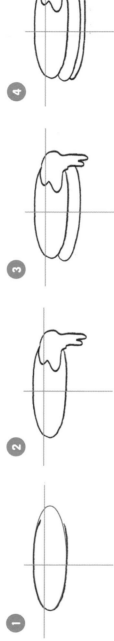

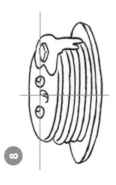

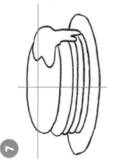

Croissant

1

2

3

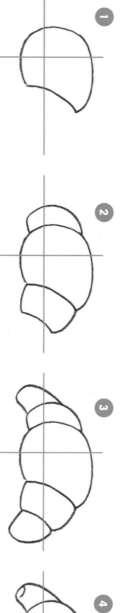

4

5

6

7

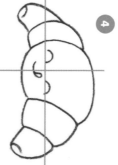

☆ Pain au Chocolat ☆

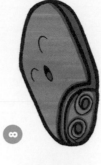

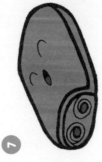

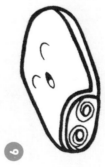

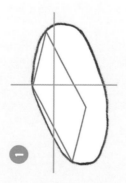

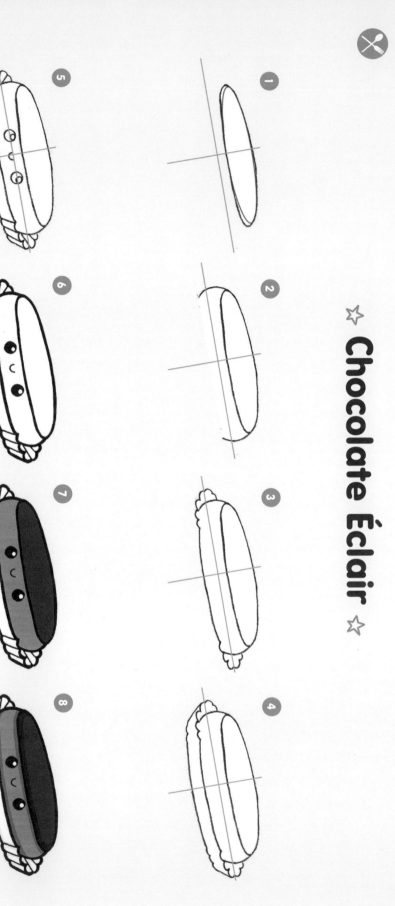

Chocolate Éclair

Chocolate Choux Bun

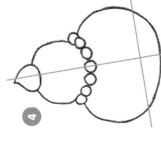

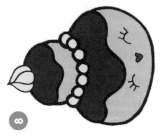

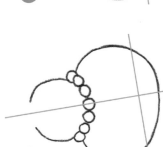

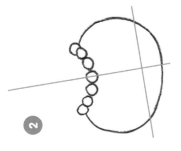

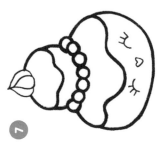

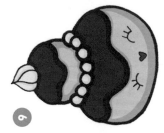

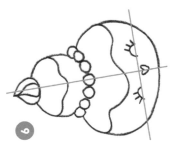

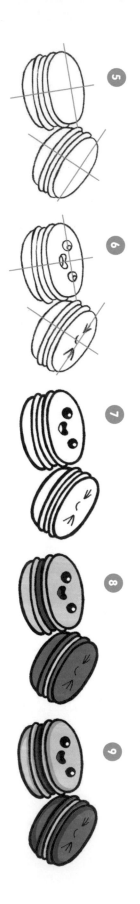

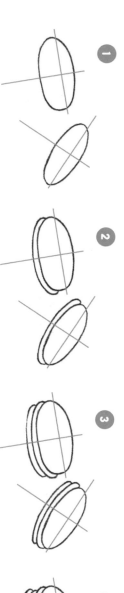

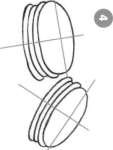

Macarons

1

2

3

4

5

6

7

8

9

☆ Donut ☆

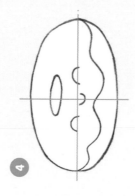

5

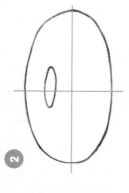

6

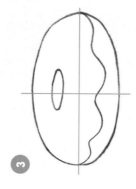

1

2

3

4

7

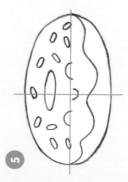

8

Candyfloss

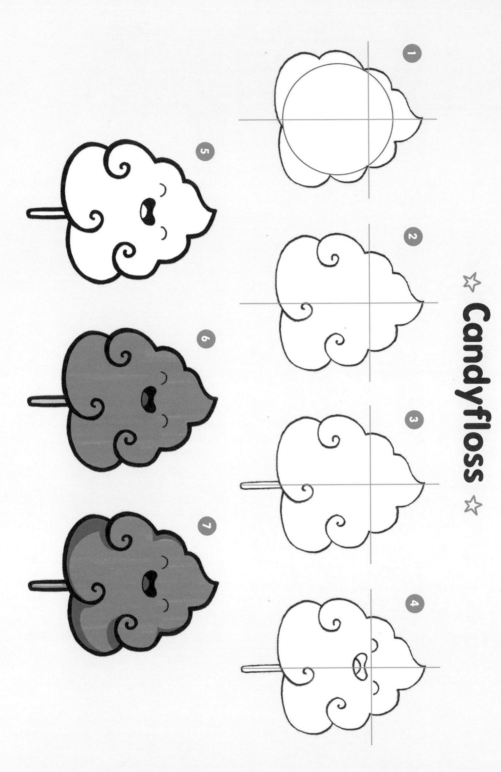

Toffee Apple

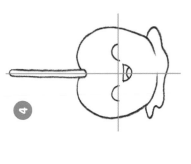

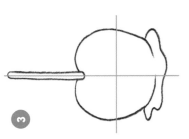

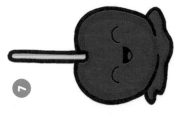

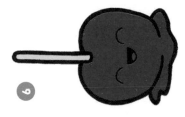

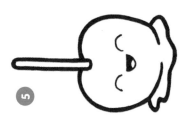

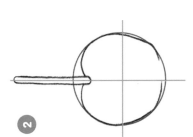

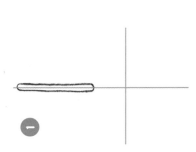

Popcorn

1

2

3

4

5

6

7

8

9

☆ Candy Cane ☆

4

1

2

3

5

6

7

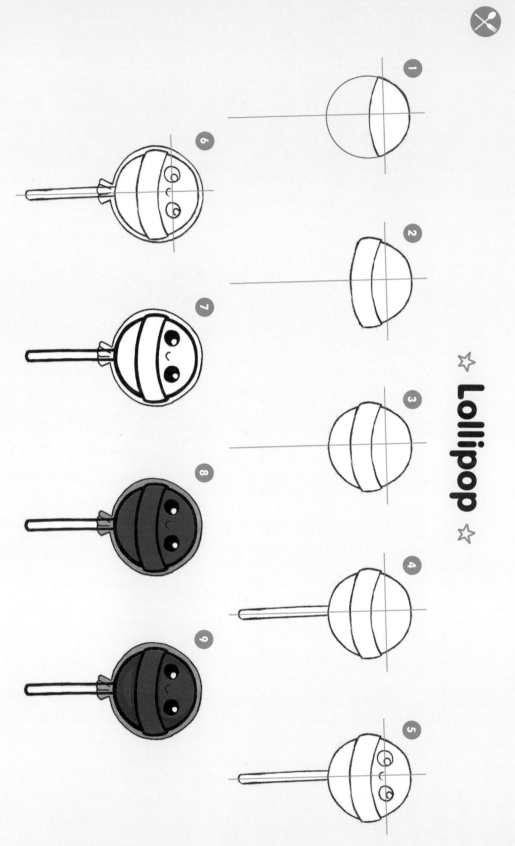

☆ Lollipop ☆

Sweet

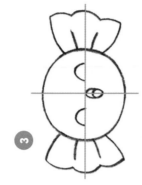

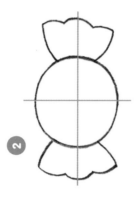

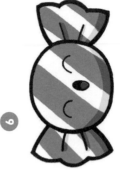

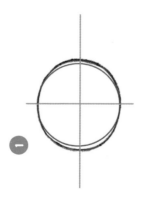

Easter Basket

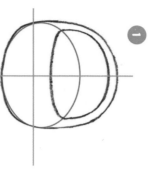

1

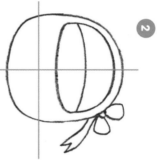

2

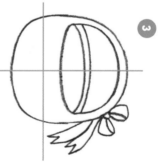

3

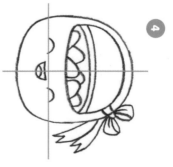

4

☆ Easter Egg ☆

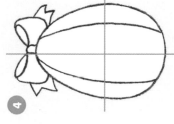

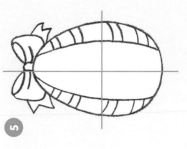

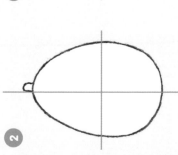

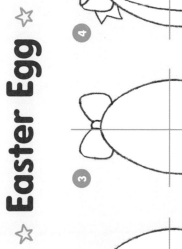

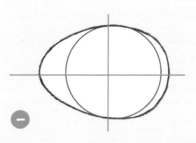

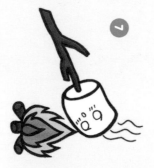

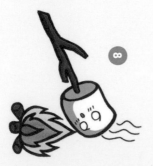

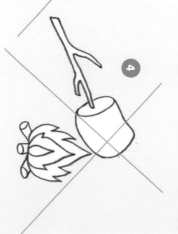

Marshmallow ☆

1

2

3

4

5

6

7

8

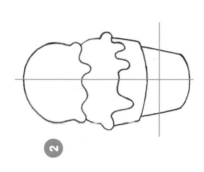

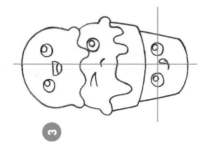

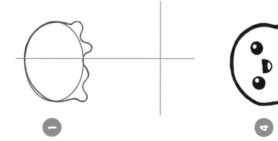

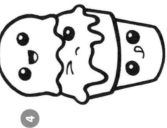

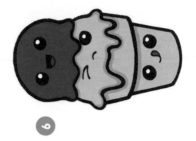

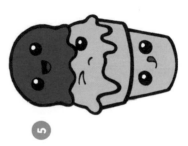

Ice Cream Cone

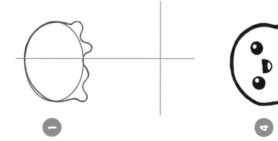

181

Sundae

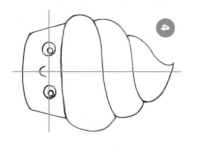

1

2

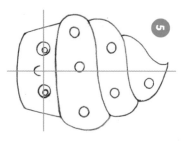

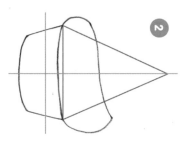

3

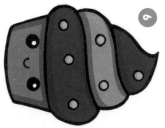

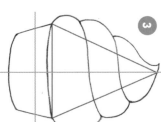

5

4

6

☆ Soft Ice Cream ☆

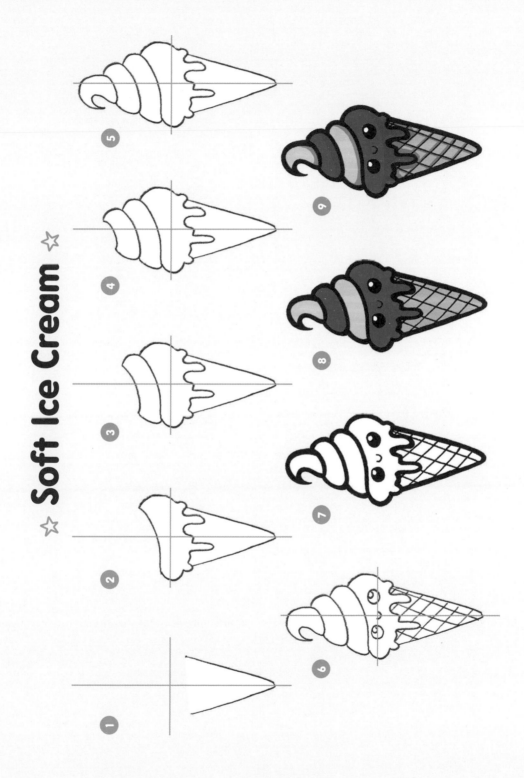

Ice Lolly

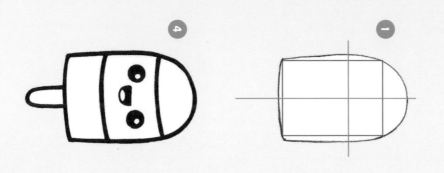

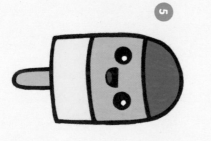

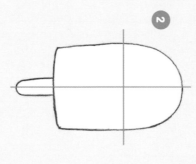

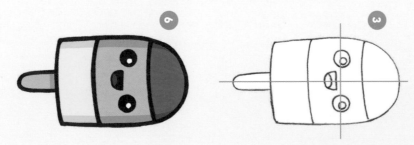

Choc Ice

2

3

4

1

5

6

7

8

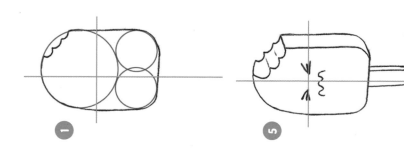

Fridge

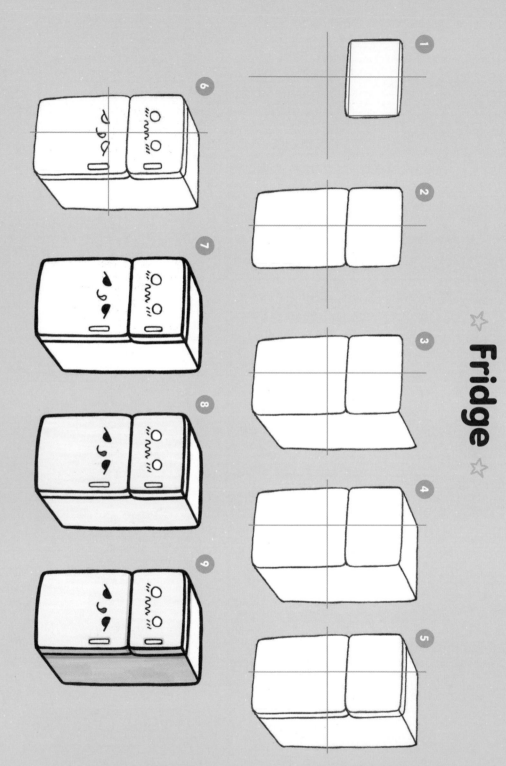

☆ Oven ☆

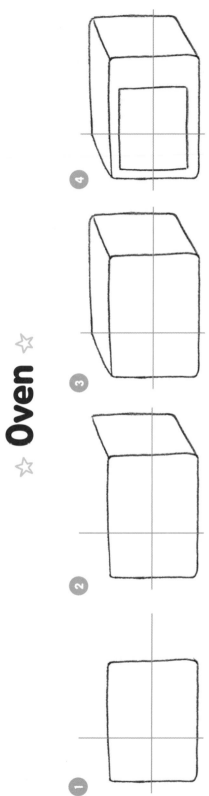

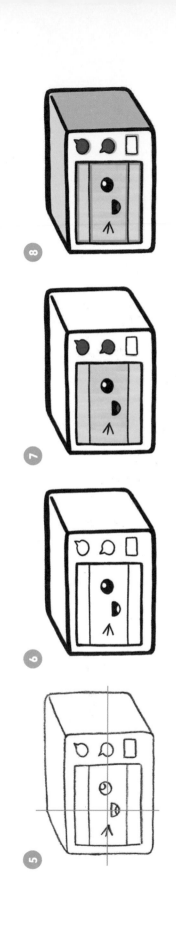

☆ Toaster ☆

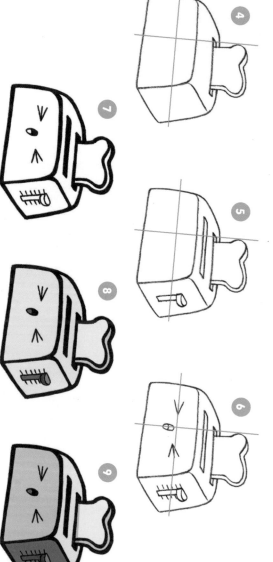

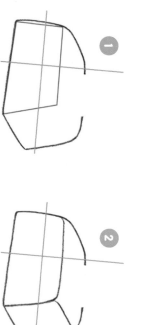

☆ Kettle ☆

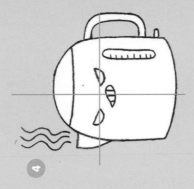

7

4

6

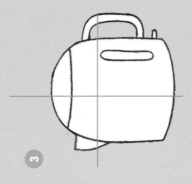

3

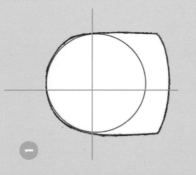

5

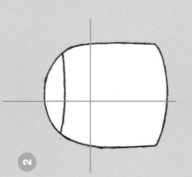

2

1

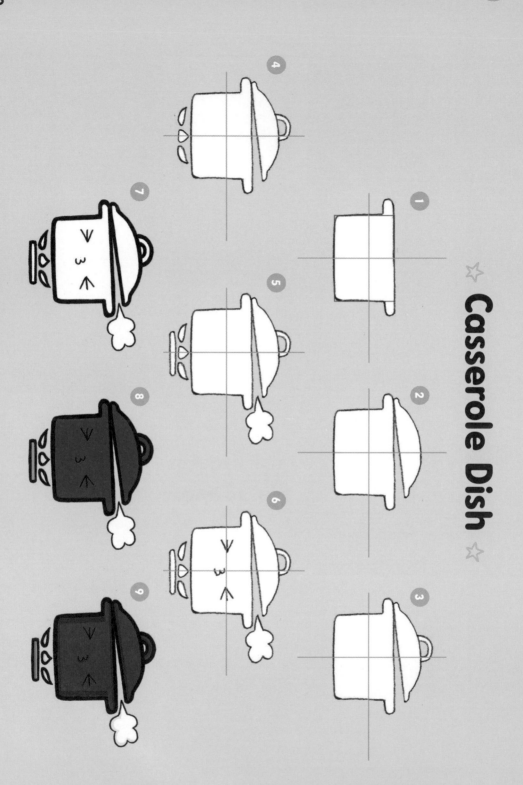

Casserole Dish

190

☆ Cauldron ☆

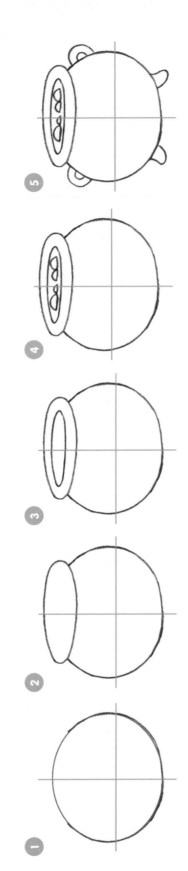

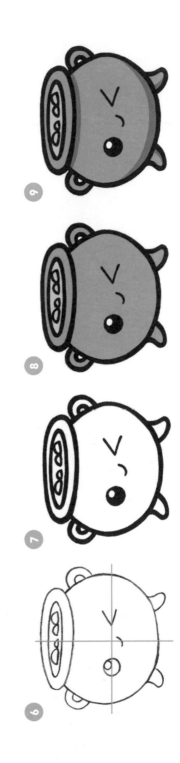

☆ Saucepan ☆

1

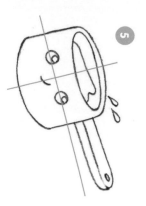

2

3

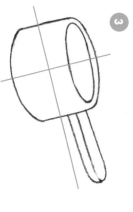

4

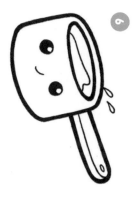

5

6

7

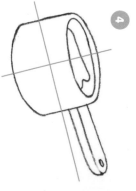

8

☆ Ladle ☆

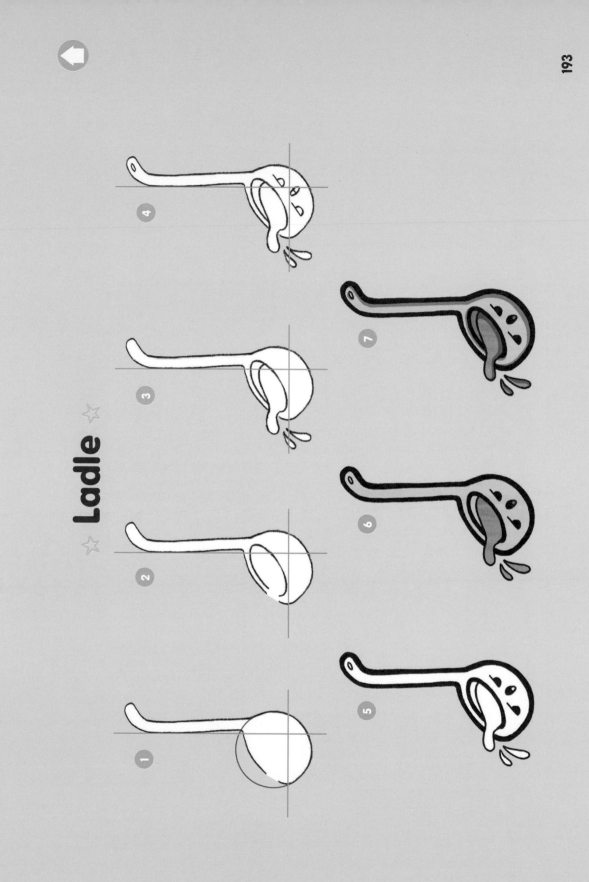

1

2

3

4

5

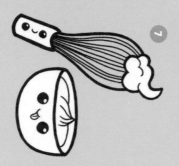

6

7

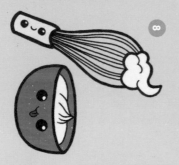

8

9

☆ Whisk and Bowl ☆

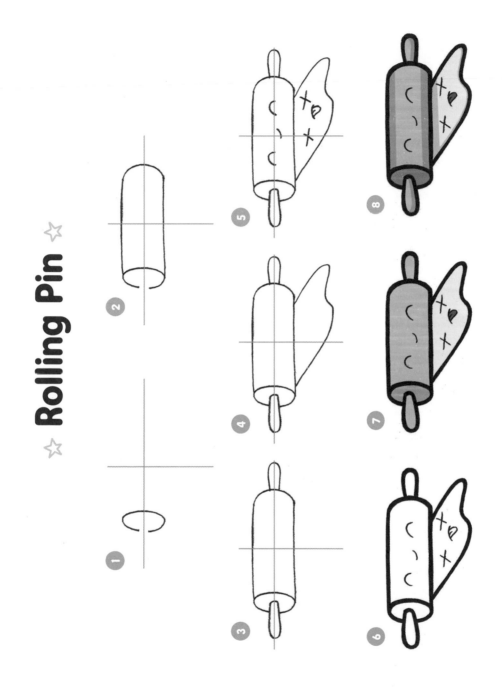

☆ Rolling Pin ☆

☆ **Knife** ☆

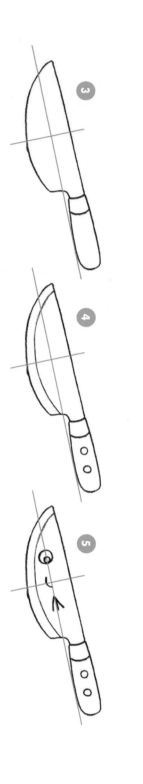

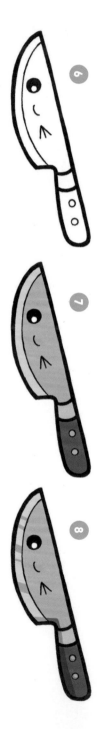

☆ Cutlery ☆

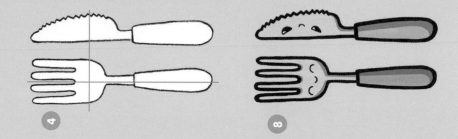

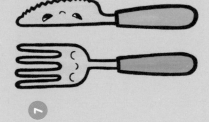

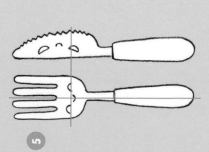

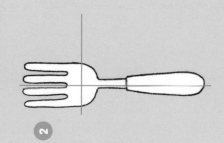

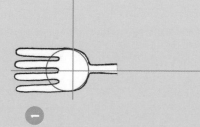

Grocery Bag

1

2

3

4

5

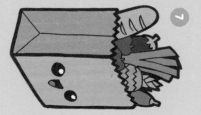

6

7

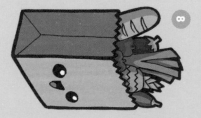

8

☆ Dustbin ☆

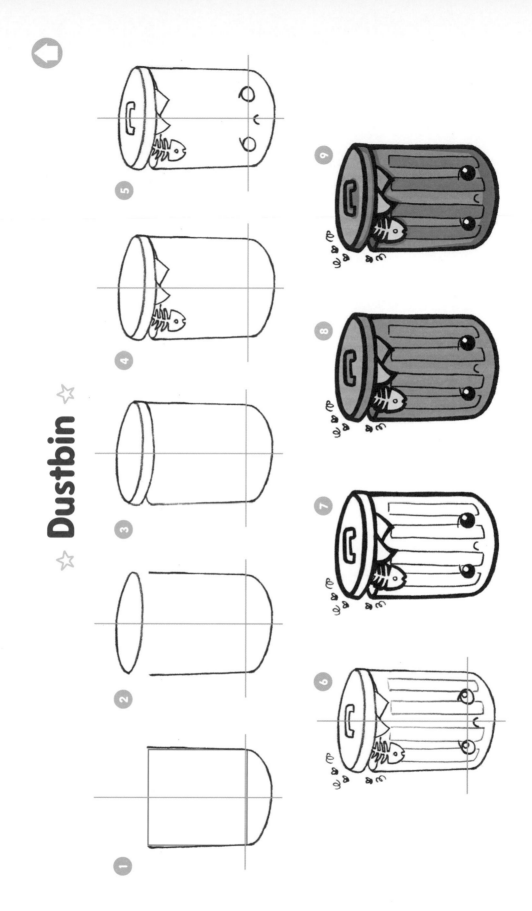

Flask ☆ ☆

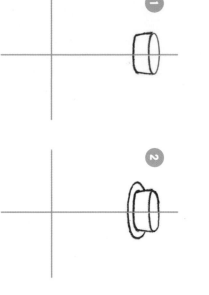

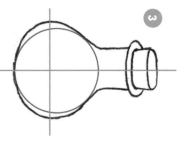

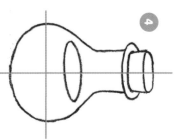

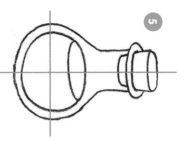

☆ Teeth ☆

1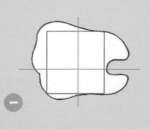

2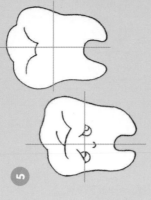

3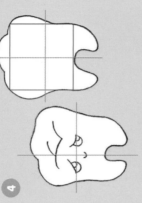

4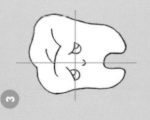

5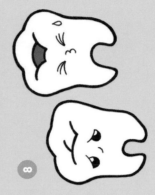

6

7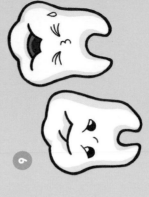

8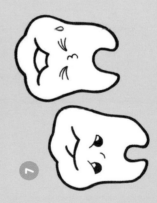

9

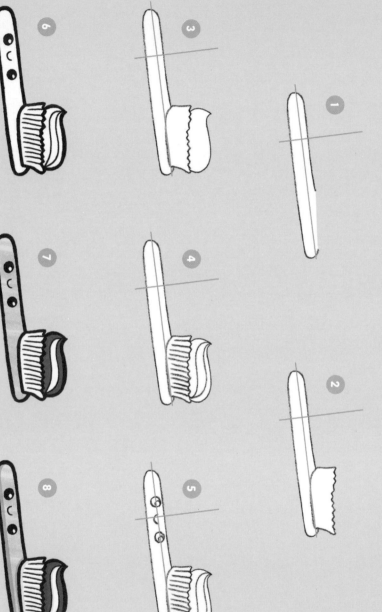

☆ **Toothbrush** ☆

☆ Toothpaste ☆

①

②

③

④

⑤

⑥

⑦

⑧

⑨

☆ **Plaster** ☆

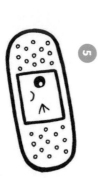

1

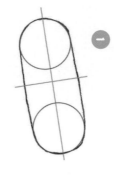

2

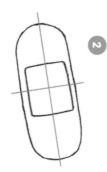

3

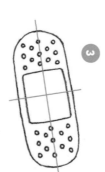

4

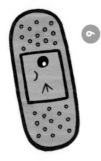

5

6

7

Thermometer ☆

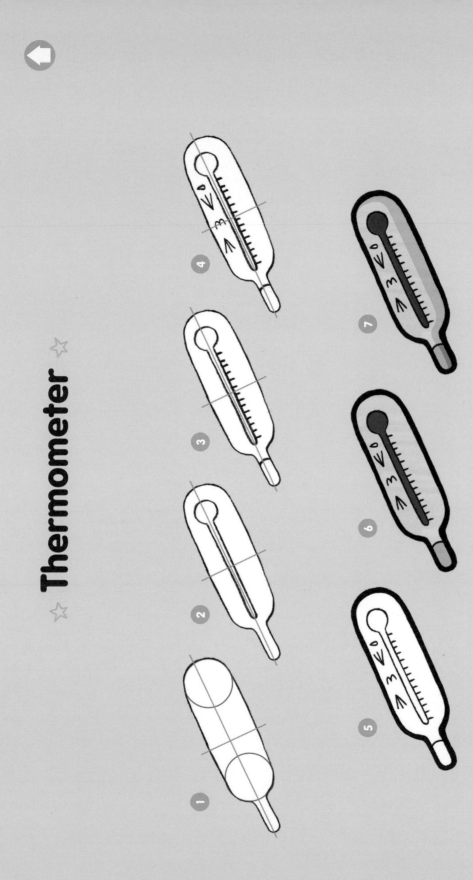

Poop and Paper

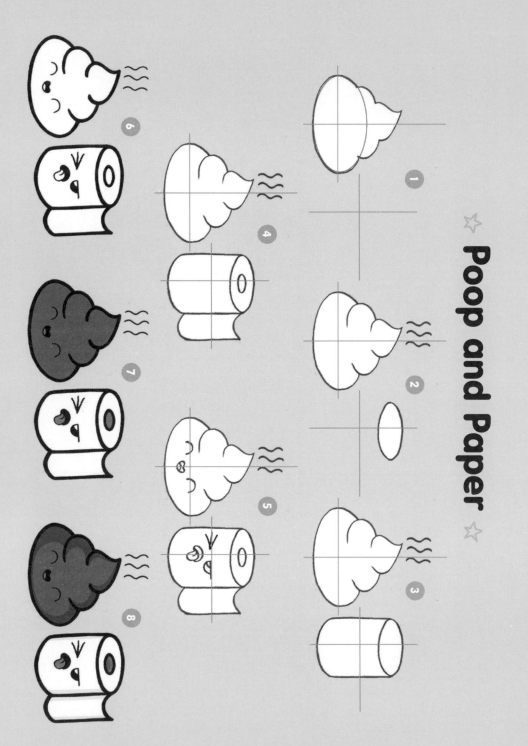

☆ Tissues ☆

1

2

3

4

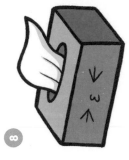

5

6

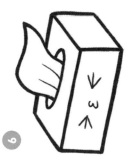

7

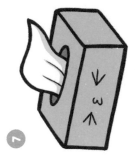

8

☆ Soap ☆

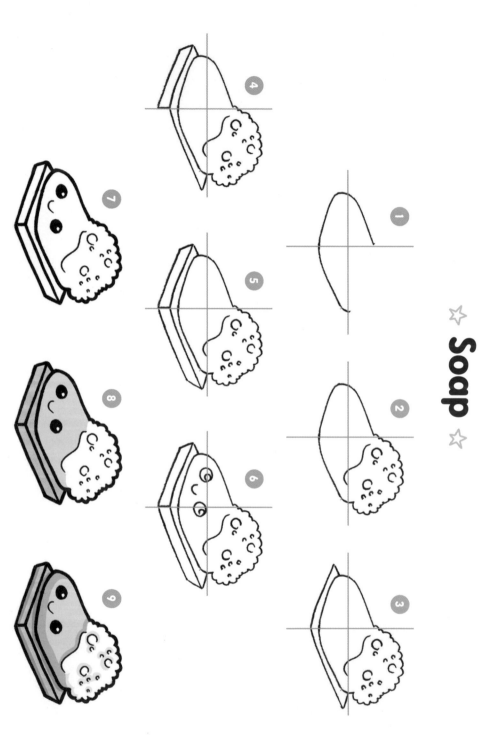

☆ Bathtub ☆

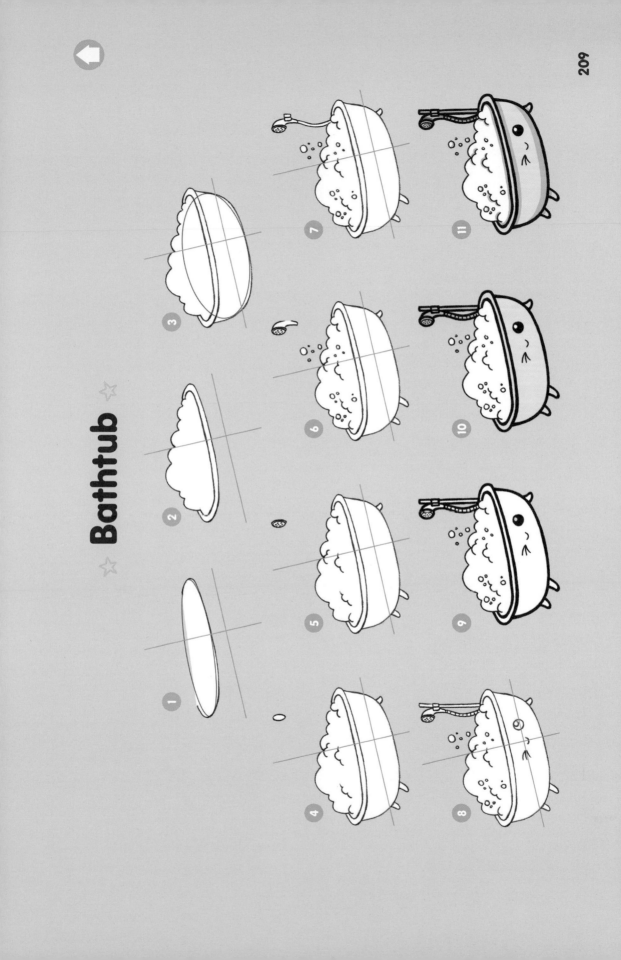

Perfume ☆

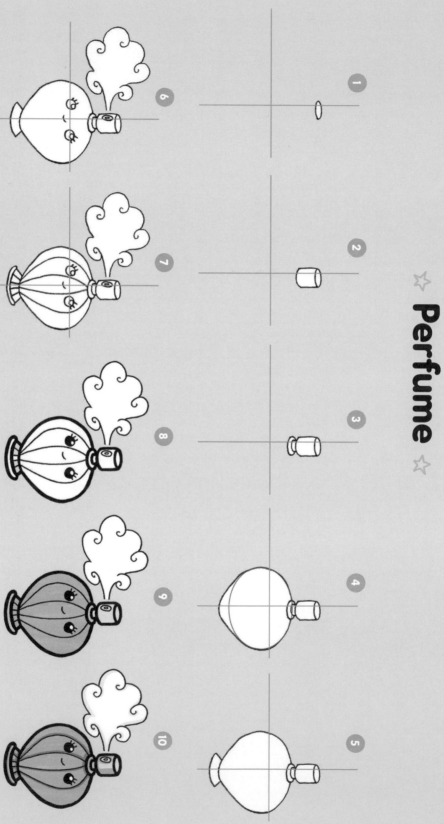

☆ Lipstick ☆

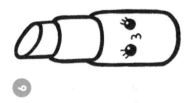

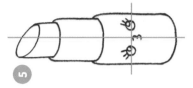

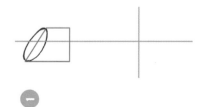

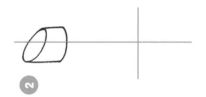

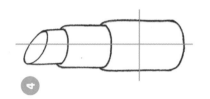

☆ **Nail Polish** ☆

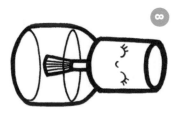

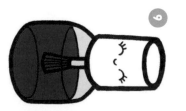

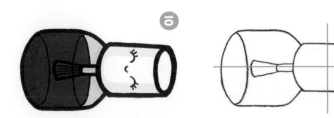

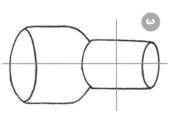

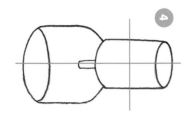

☆ Make-Up Palette ☆

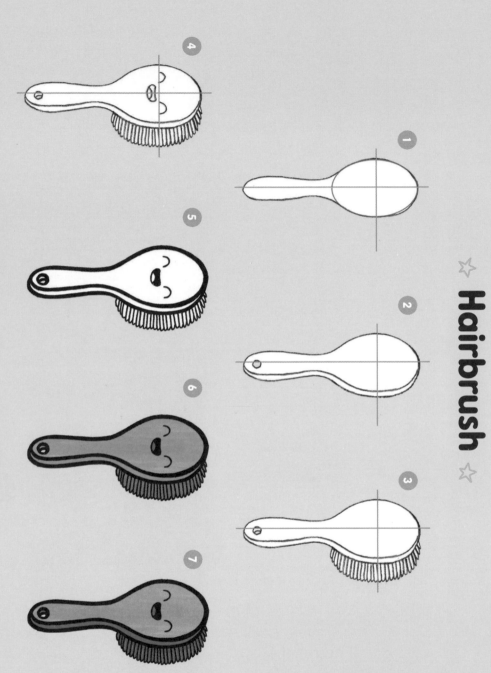

Hairbrush

Hairdryer ☆

☆

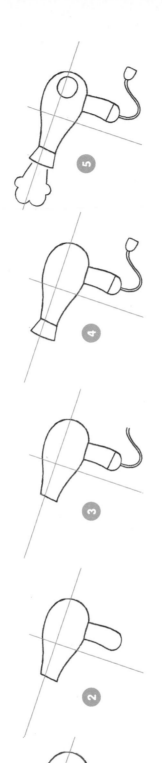

1

2

3

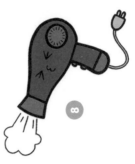

4

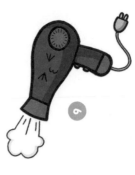

5

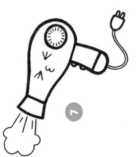

6

7

8

9

☆ Washing Machine ☆

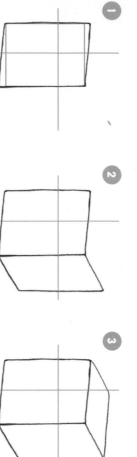

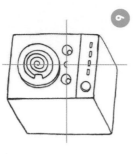

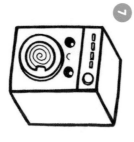

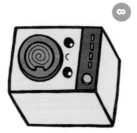

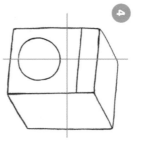

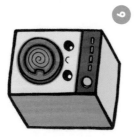

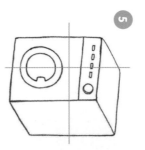

☆ Iron ☆

5

4

3

2

1

9

8

7

6

Vacuum Cleaner

1

2

3

4

5

6

7

8

9

10

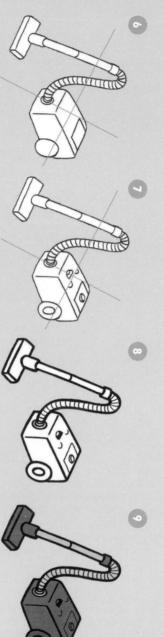

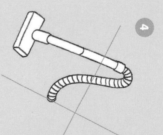

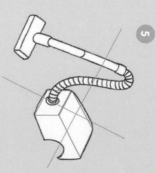

☆ Table Lamp ☆

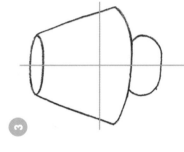

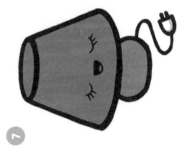

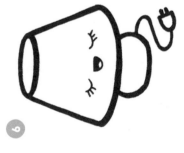

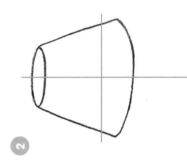

Alarm Clock ☆ ☆

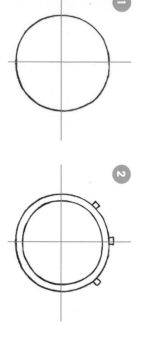

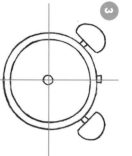

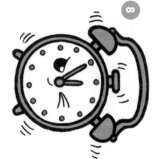

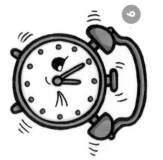

☆ Bed ☆

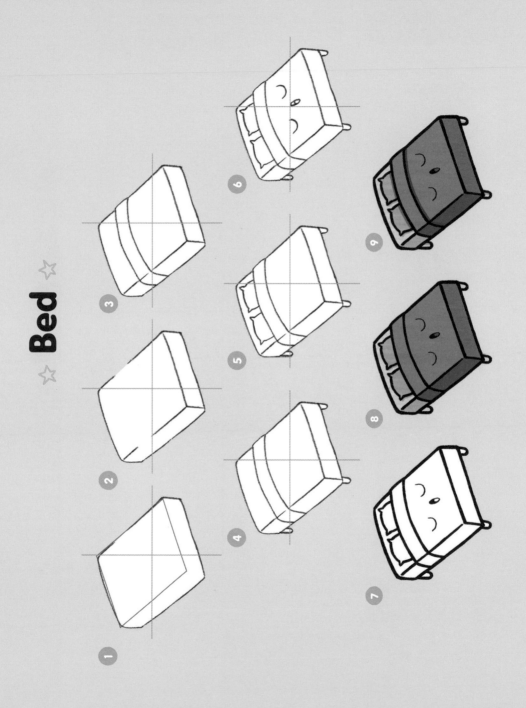

Armchair

1

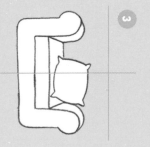

2

3

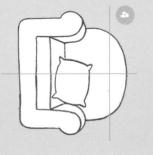

4

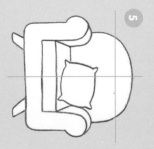

5

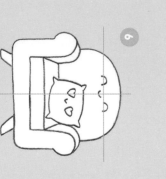

6

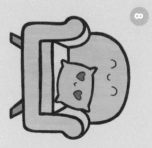

7

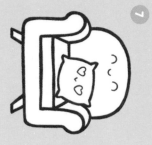

8

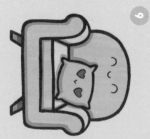

9

☆ Office Chair ☆

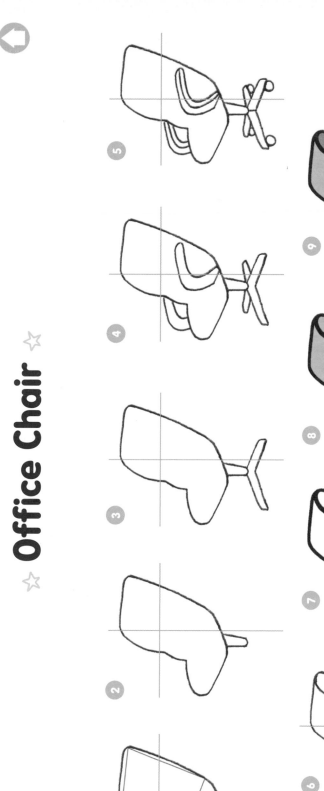

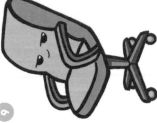

☆ Chair ☆

1

2

3

4

5

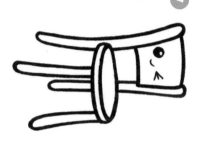

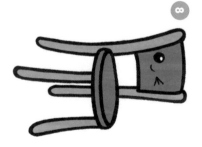

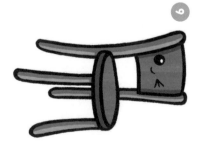

6

7

8

9

☆ Wardrobe ☆

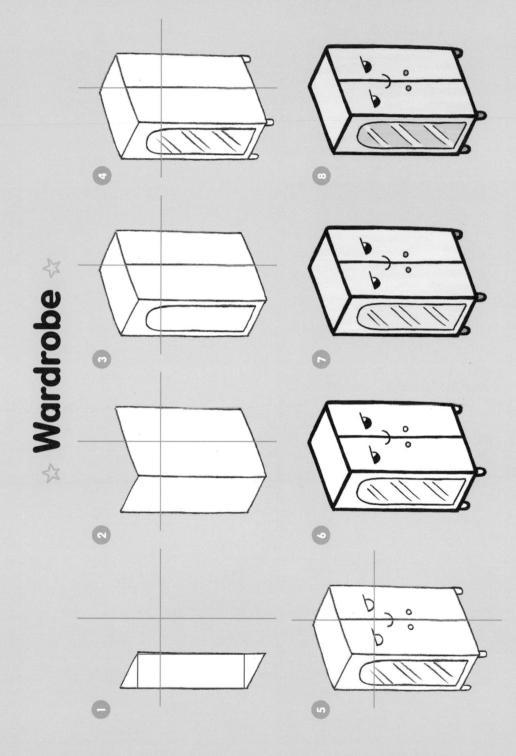

Treasure Chest

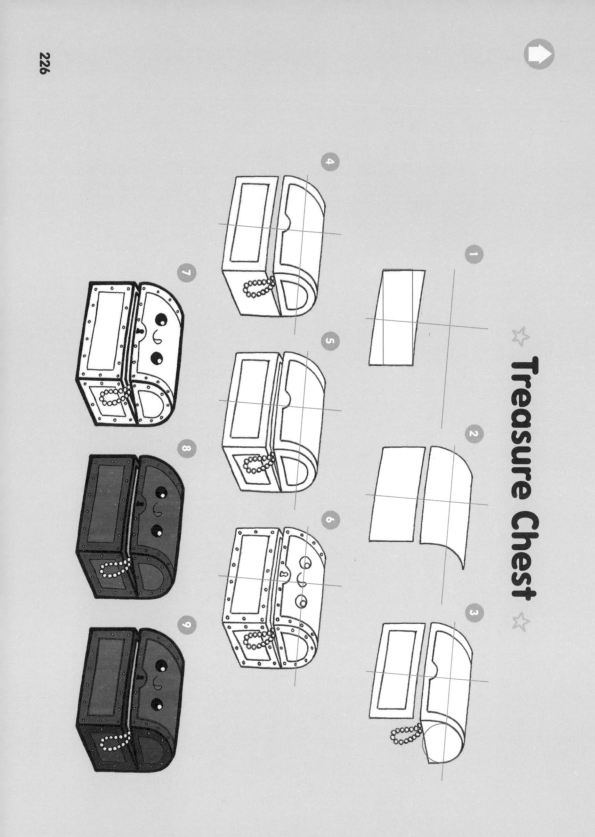

☆ Cardboard Box ☆

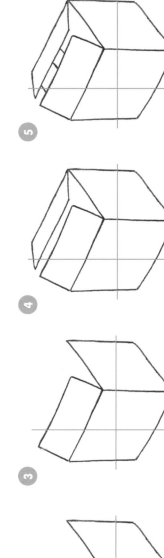

1

2

3

4

5

6

7

8

9

Bucket

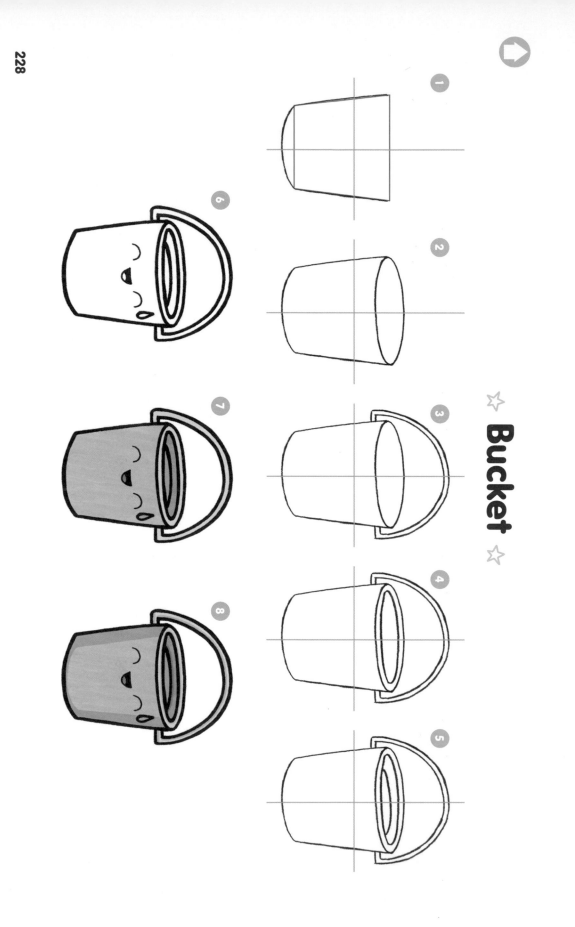

Watering Can

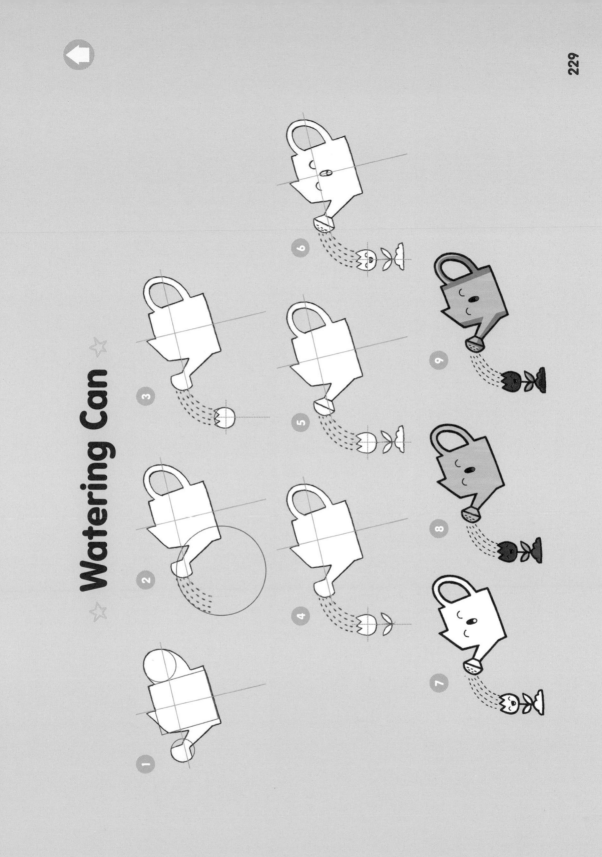

Gardening Tools

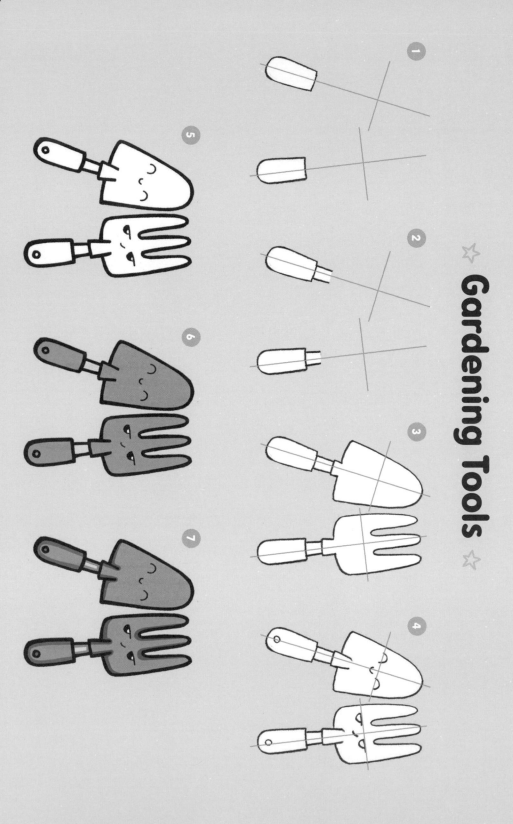

☆ Swiss Army Knife ☆

1

2

3

4

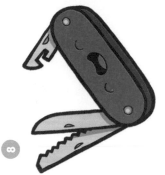

5

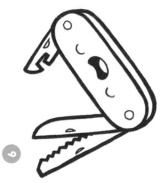

6

7

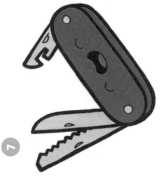

8

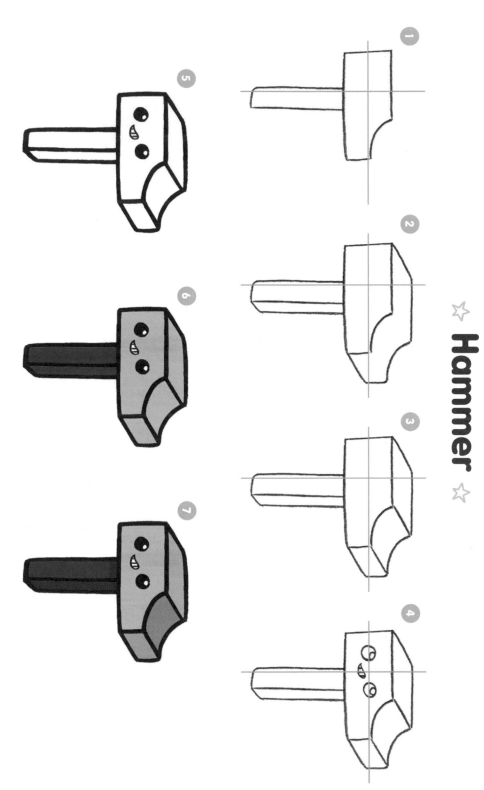

☆ **Hammer** ☆

1

2

3

4

5

6

7

Spanner

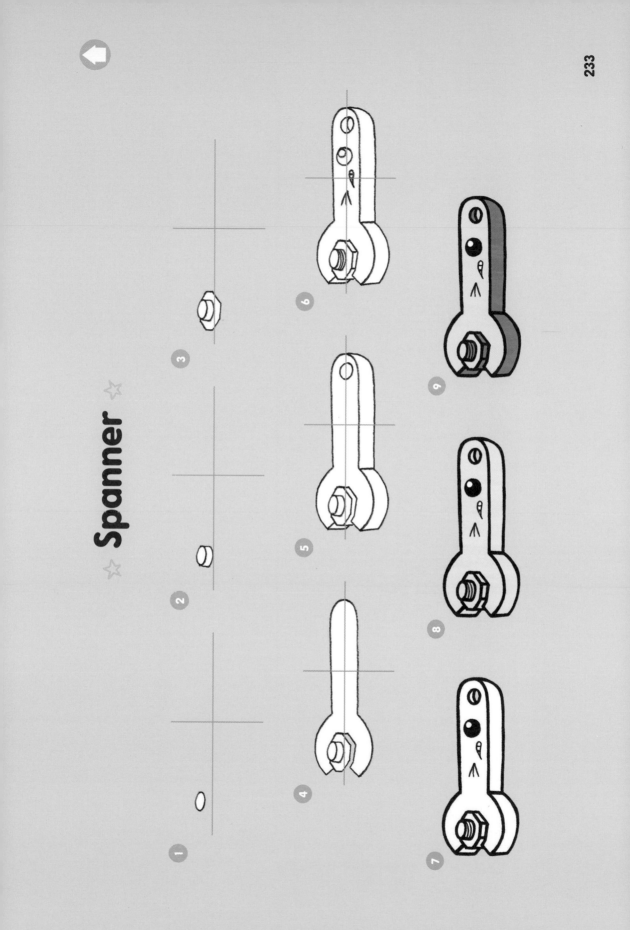

Screwdriver

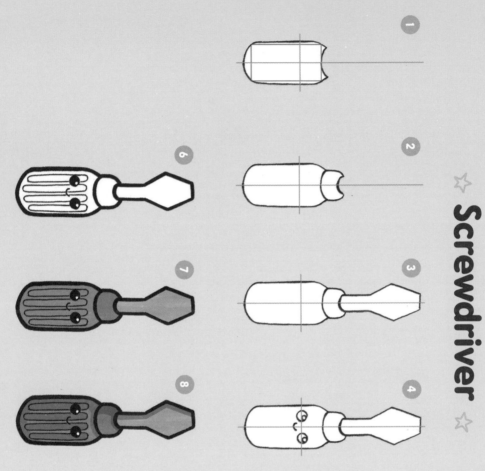

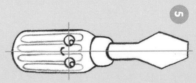

☆ Screw ☆

5

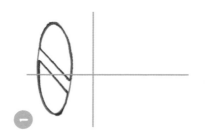

4

3

2

1

8

7

6

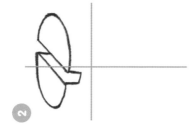

Paint Pot ☆

1

2

3

4

5

6

7

8

9

☆ Paint Palette ☆

1

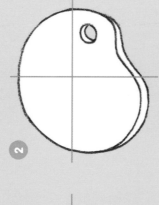

2

3

4

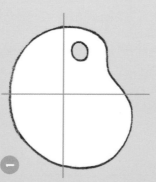

5

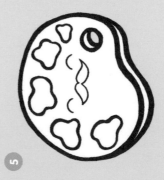

6

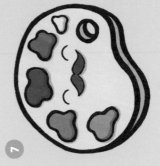

7

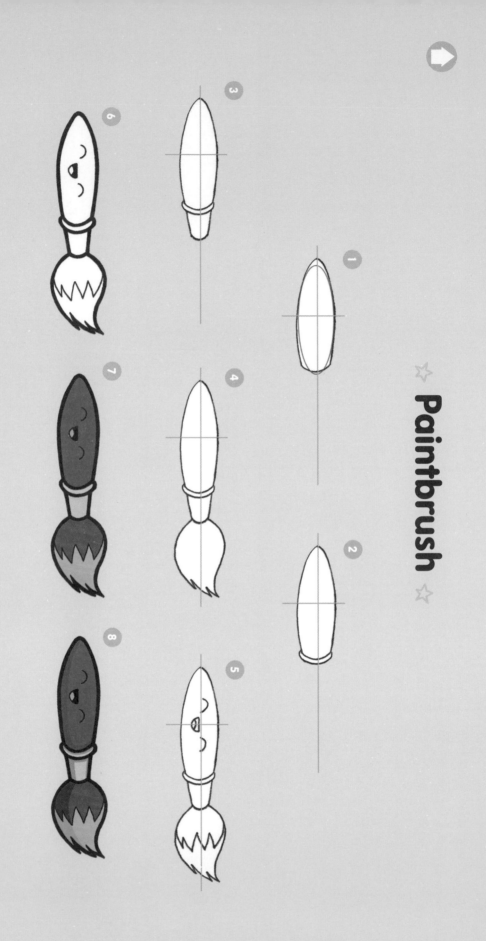

Paintbrush

☆ Pencil Crayon ☆

1

2

3

4

5

6

7

8

Pencil Sharpener ☆ ☆

☆ Pencil Case ☆

1

2

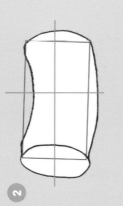

3

4

5

6

7

8

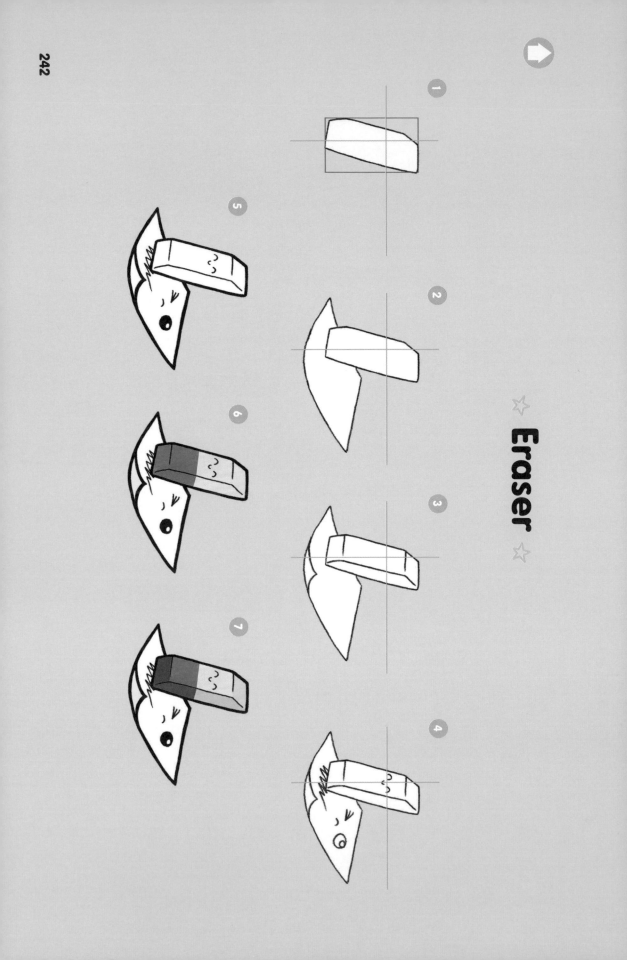

☆ Eraser ☆

☆ Scissors ☆

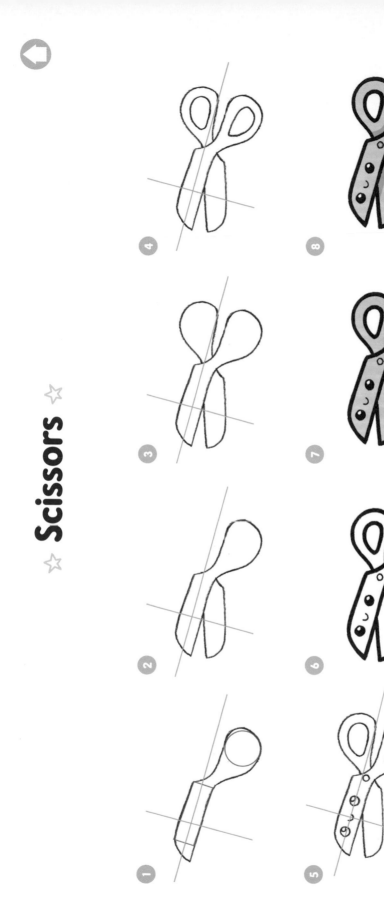

Sticky Tape ☆

5

1

2

3

4

6

7

8

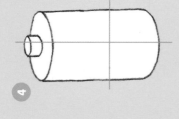

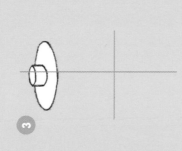

Battery ☆

☆

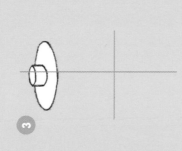

1

2

3

4

5

6

7

8

9

Torch ☆ ☆

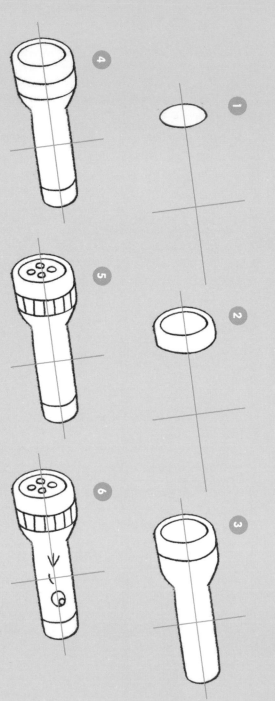

1

2

3

4

5

6

7

8

9

☆ Lightbulb ☆

4

3

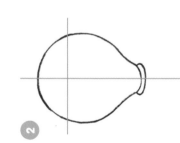

2

1

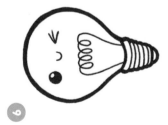

8

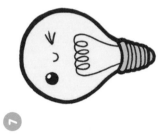

7

6

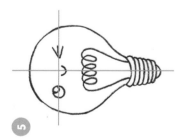

5

☆ **Match** ☆

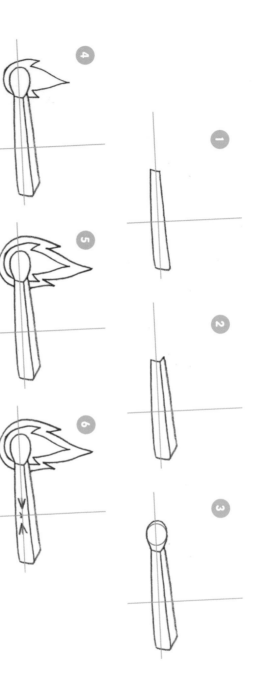

1

4

2

5

3

6

7

8

9

Candle

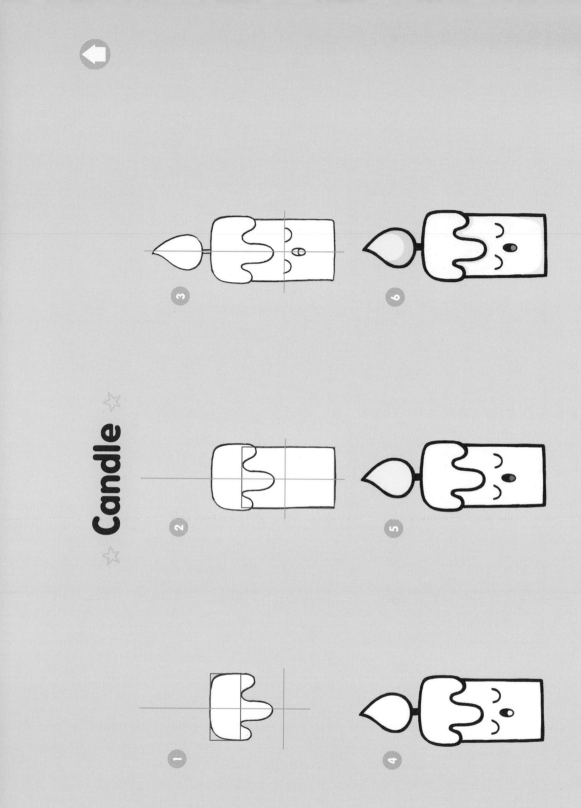

1

2

3

4

5

6

Snowglobe ☆ ☆

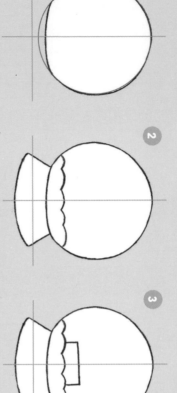

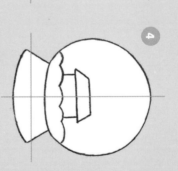

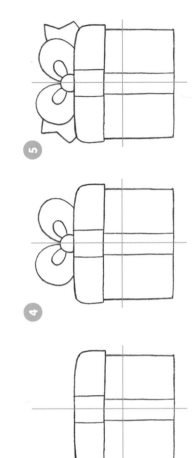

Gift ☆ ☆

1

2

3

4

5

6

7

8

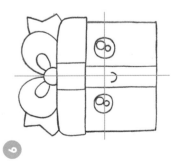

9

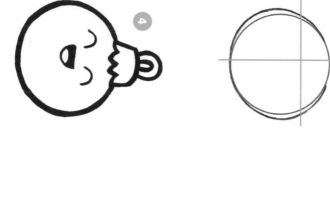

☆ **Bauble** ☆

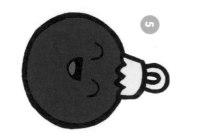

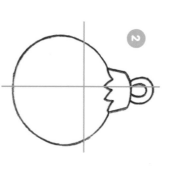

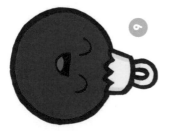

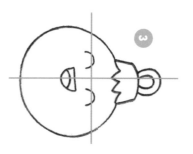

Christmas Tree

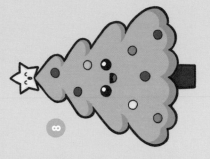

Bell ☆

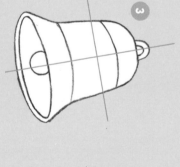

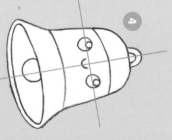

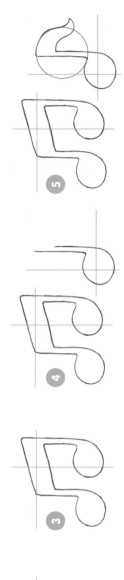

☆ Trumpet ☆

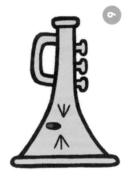

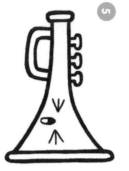

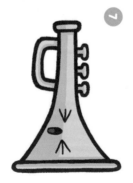

Accordion

1

3

2

4

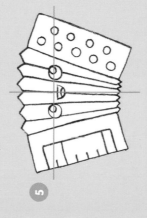

6

5

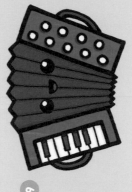

7

9

8

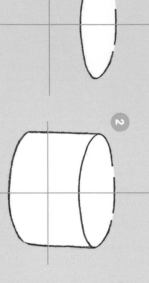

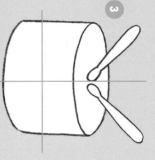

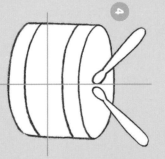

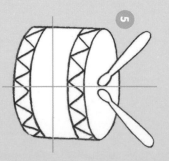

☆ **Drum** ☆

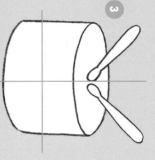

258

Maracas

1

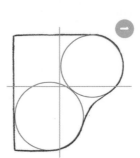

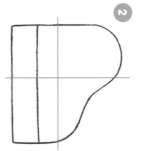

☆ **Piano** ☆

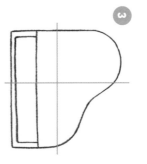

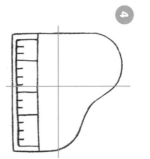

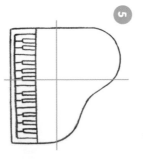

☆ Violin ☆

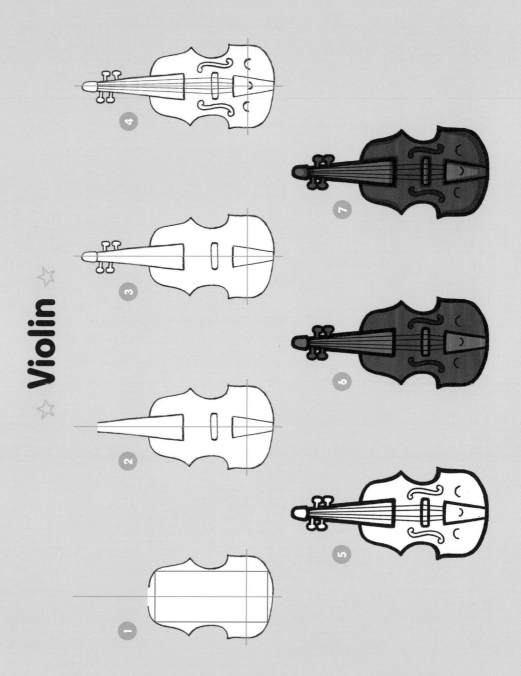

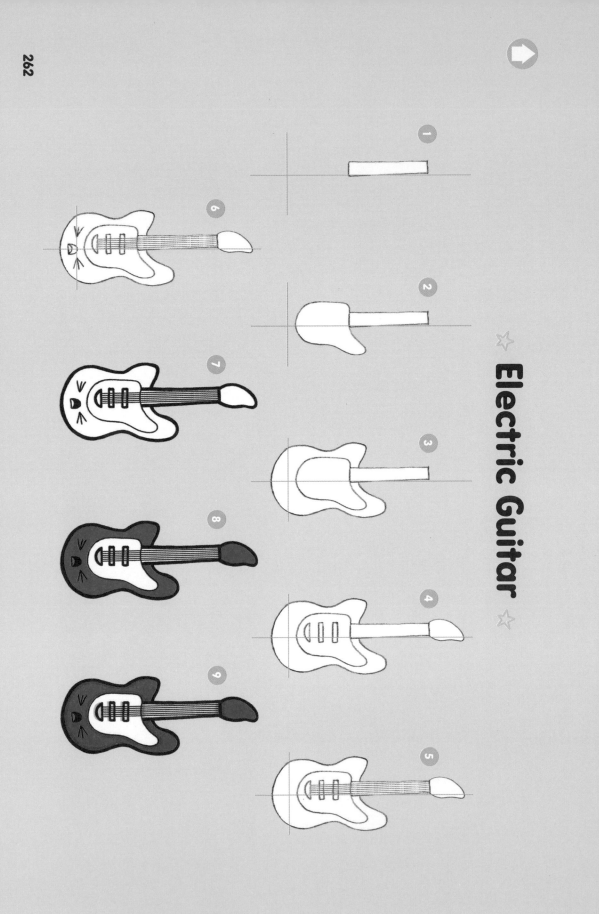

Electric Guitar

Acoustic Guitar

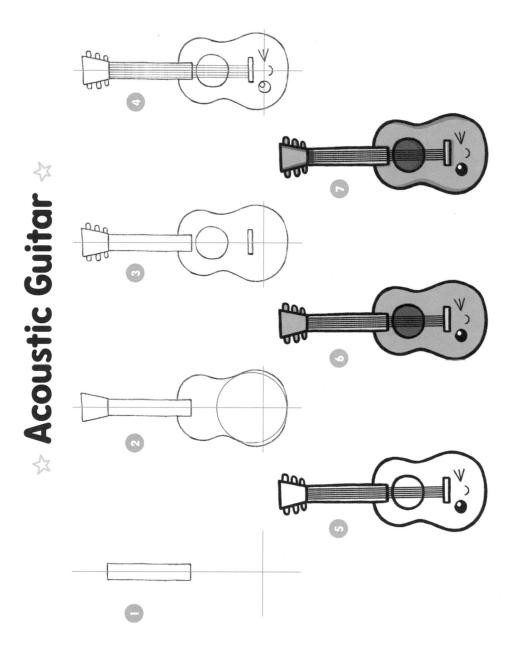

Saxophone

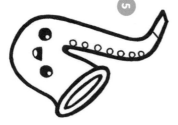

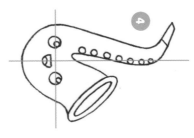

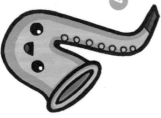

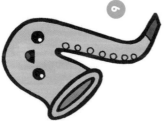

Harmonica

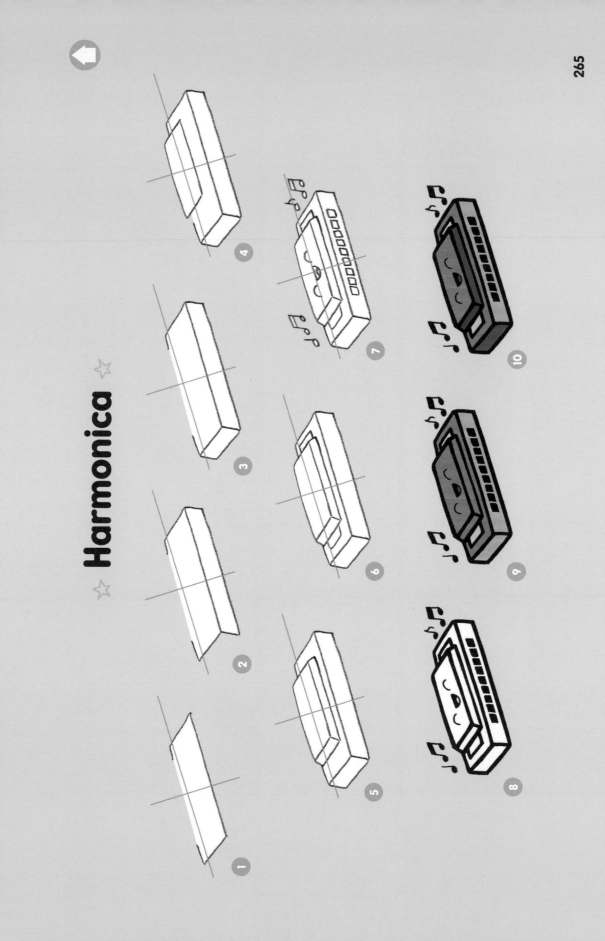

Musical Box ☆ ☆

1

2

3

4

5

6

7
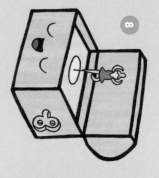

8

9
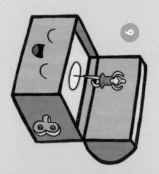

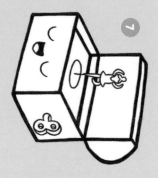

☆ Microphone ☆

5

4

3

2

1

10

9

8

7

6

☆ USB Stick ☆

1

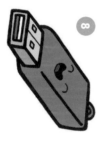

2

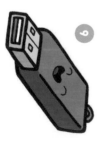

3

4

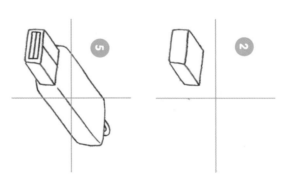

5

6

7

8

9

☆ Laptop ☆

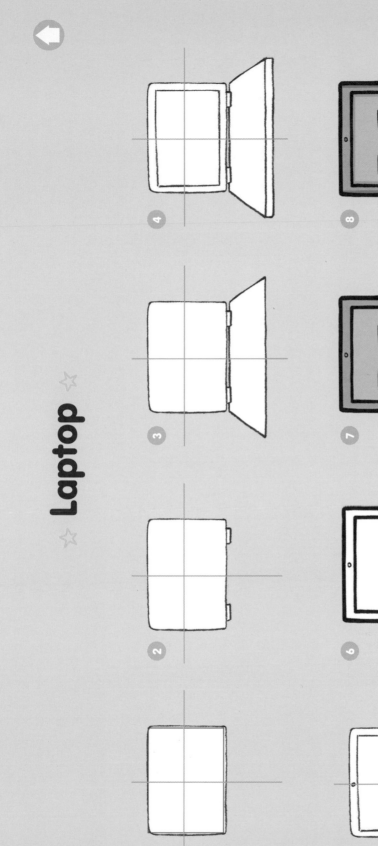

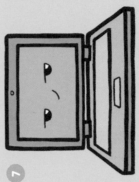

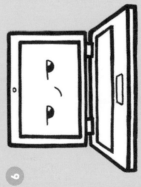

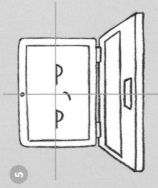

Smart Phone

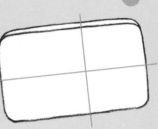

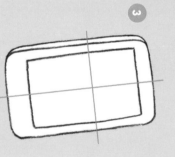

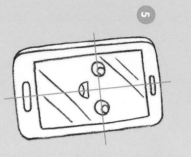

☆ Camera ☆

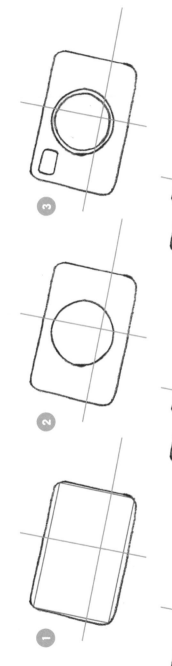

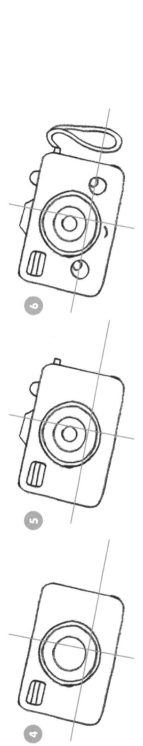

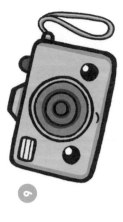

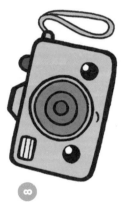

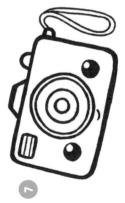

Basketball and Hoop

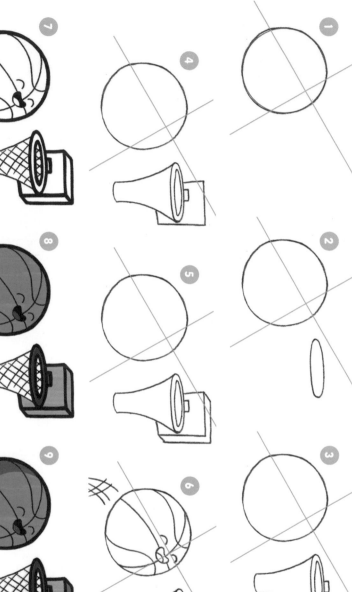

Bowling Ball and Skittle

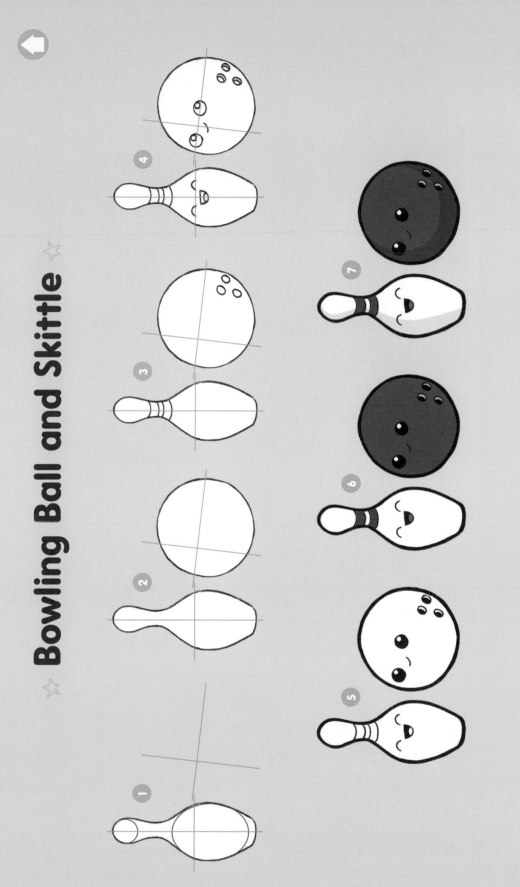

Ping Pong Ball and Paddle

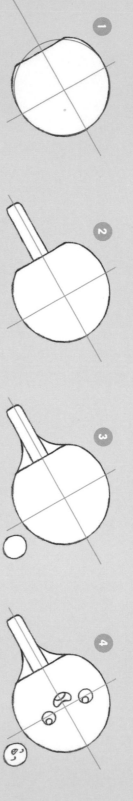

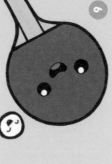

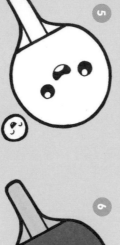

☆ **Skateboard** ☆

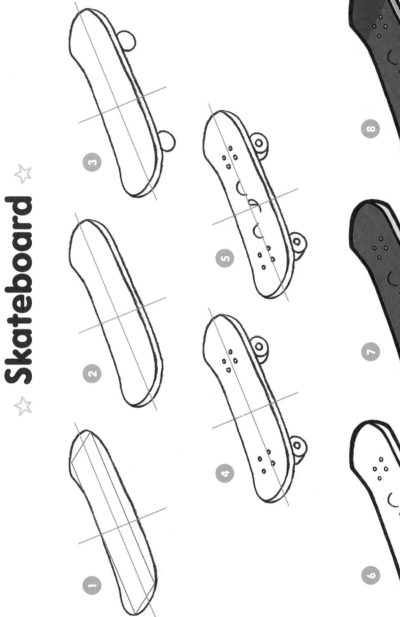

☆ **Balloon** ☆

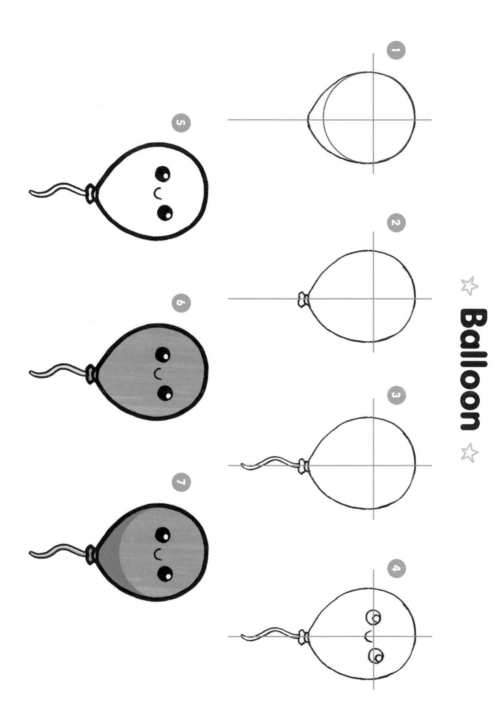

Crown

☆ ☆

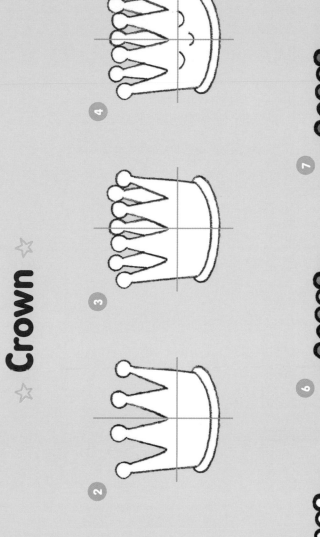

☆ Envelope ☆

1

2

3

4

5

6

7

8

☆ Book ☆

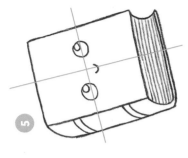

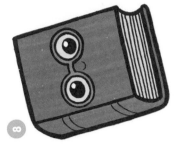

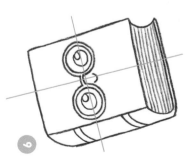

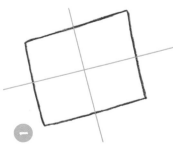

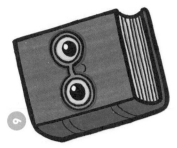

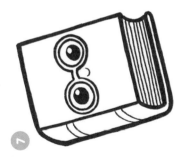

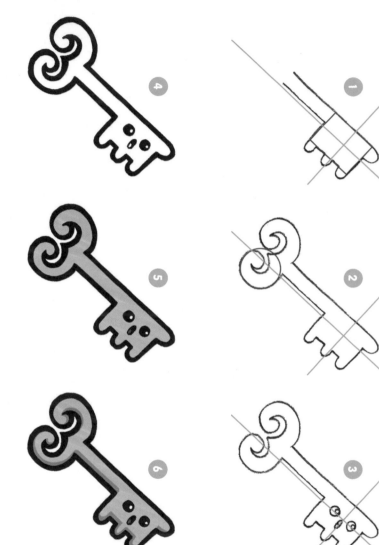

Key

Diamond ☆

1

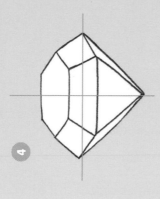

2

3

4

5

6

7

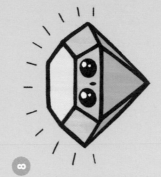

8

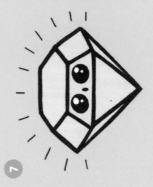

Calculator ☆ ☆

1

2

3

4

5

6

7

8

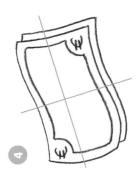

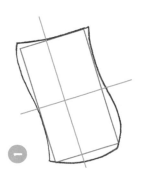

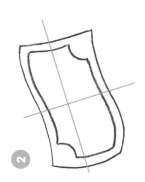

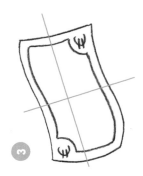

☆ Purse ☆

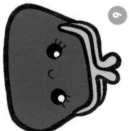

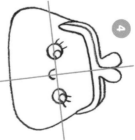

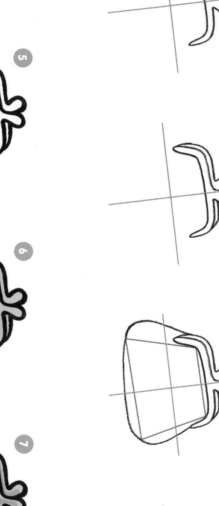

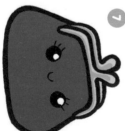

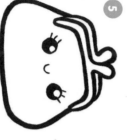

Backpack ☆

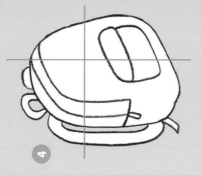 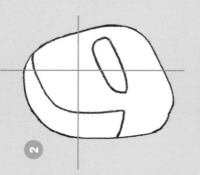 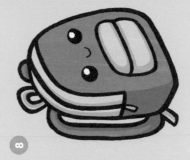

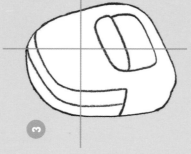 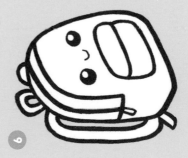 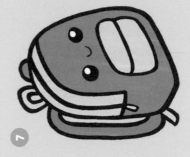

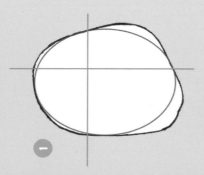 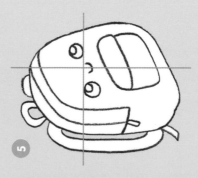

Suitcase ☆

5

6

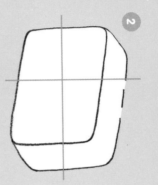

7

8

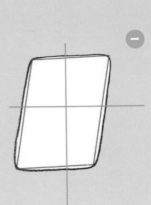

2

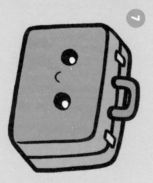

1

3

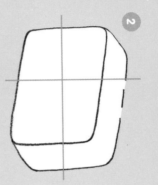

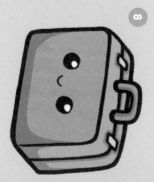

4

☆ Hat ☆

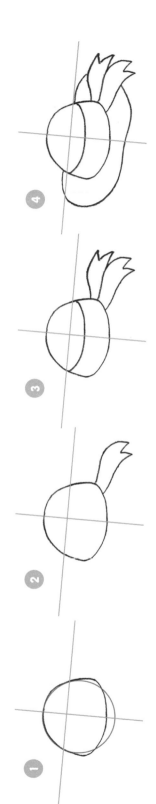

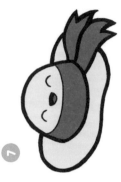

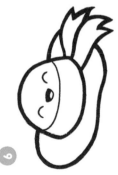

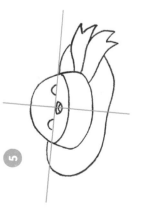

☆ **Cap** ☆

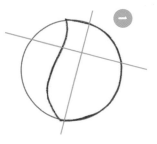

1

2

3

4

5

6

7

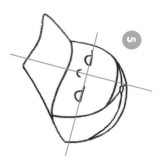

8

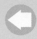

Flip-flops ☆

☆

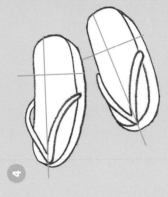

4

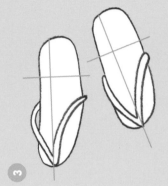

3

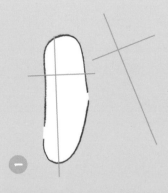

2

1

8

7

6

5

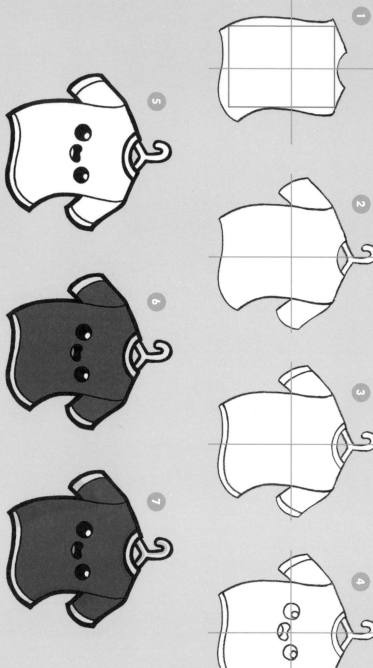

T-shirt

☆ Slippers ☆

1

2

3

4

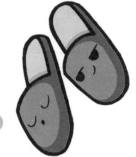

5

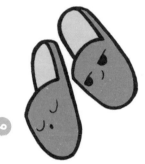

6

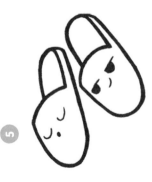

7

☆ **Fan** ☆

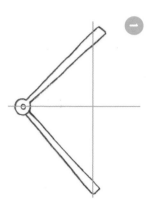

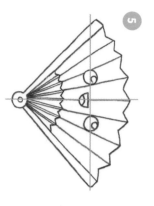

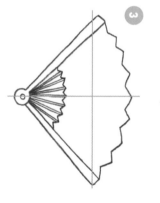

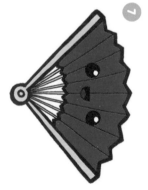

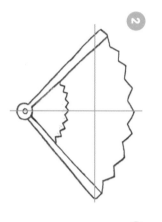

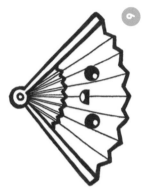

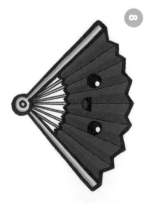

☆ Umbrella ☆

1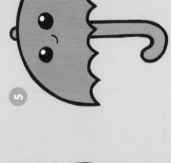

2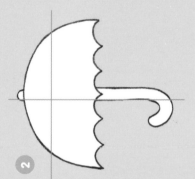

3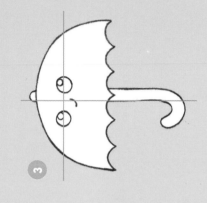

4

5

6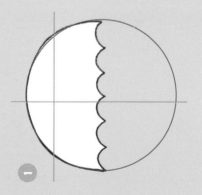

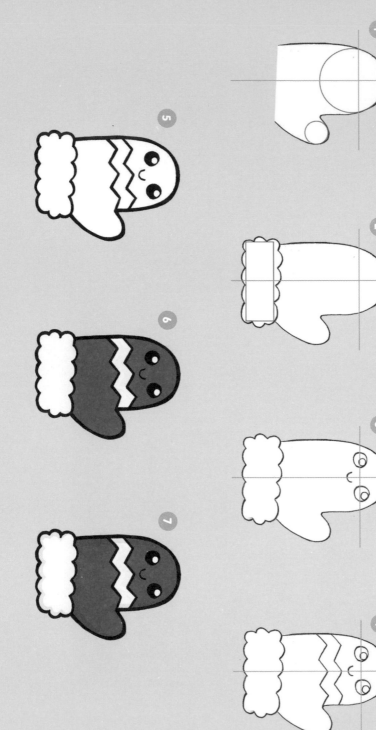

☆ Mitten ☆

Stocking ☆

1

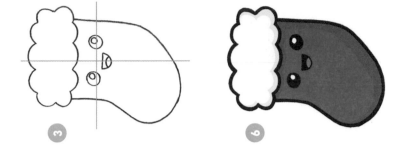

2

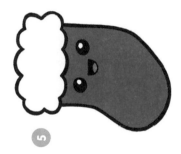

3

4

5

6

☆ **Father Christmas** ☆

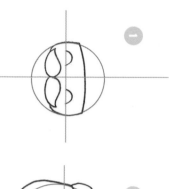

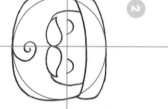

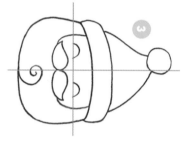

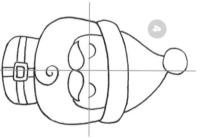

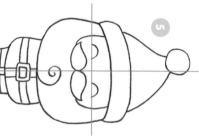

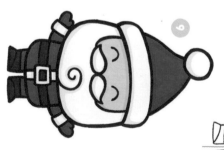

Mother Christmas

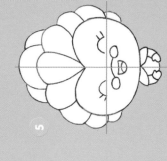

1

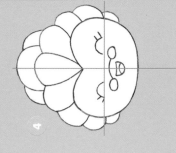

2

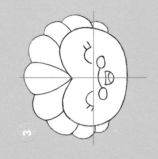

3

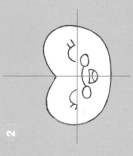

4

5

6

7

8

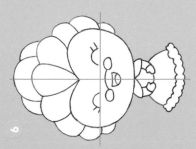

9

Snowman

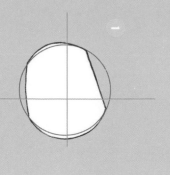

1

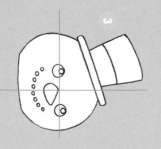

2

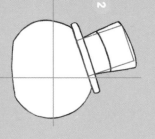

3

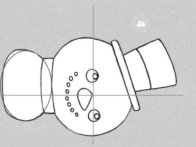

4

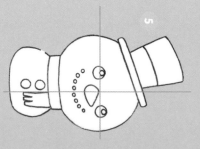

5

6

7

8

9

Elf ☆

☆

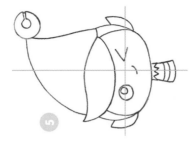

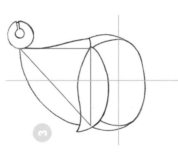

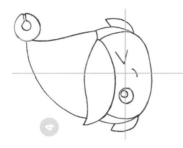

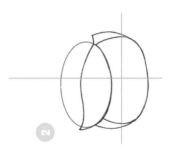

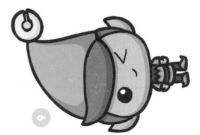

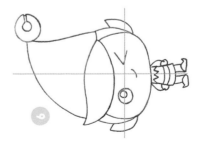

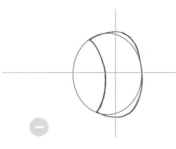

☆ Angel ☆

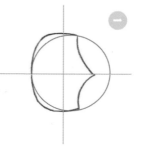

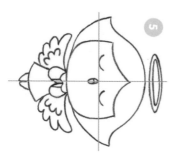

Devil

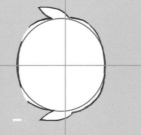

Skeleton

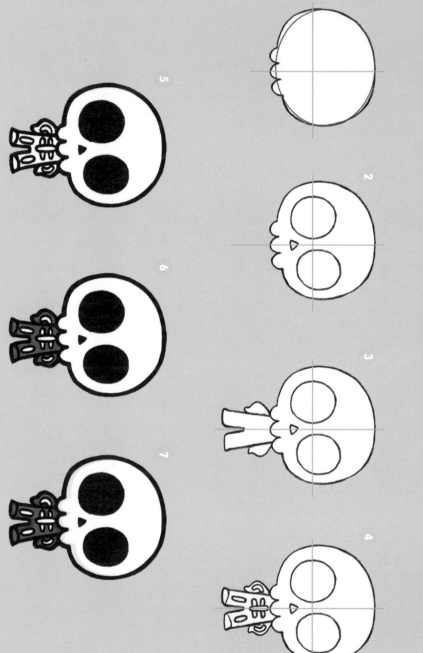

☆ Vampire ☆

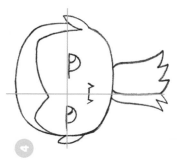

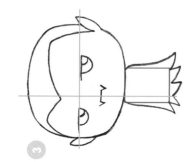

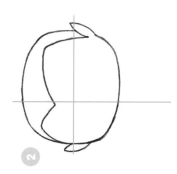

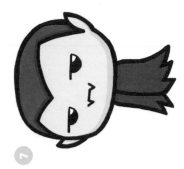

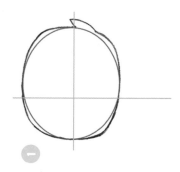

Witch ☆ ☆

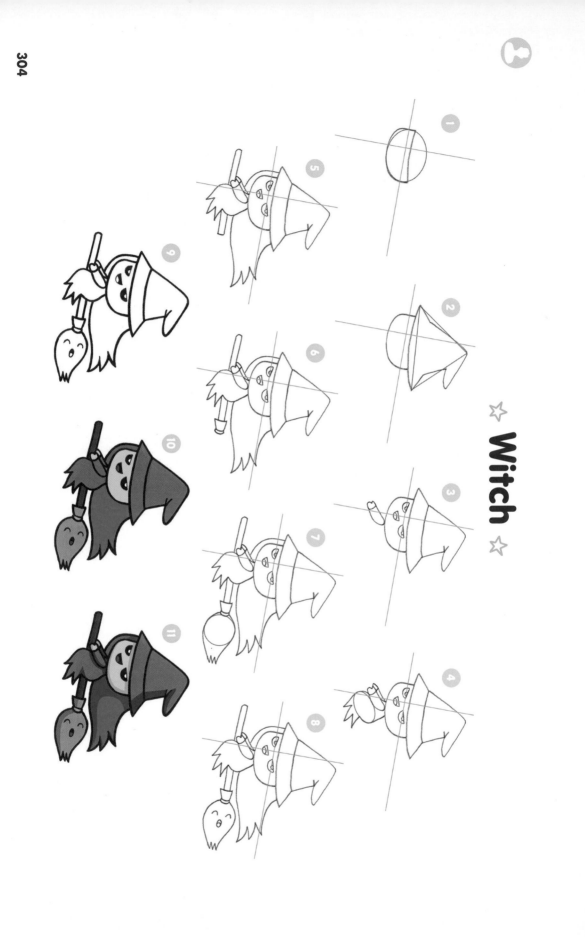

Ghost

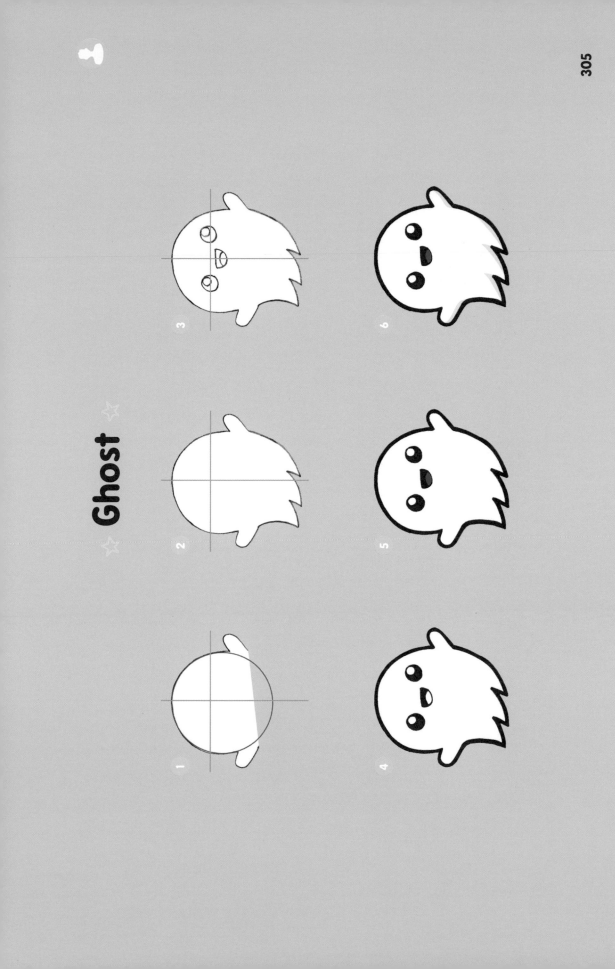

Voodoo Doll

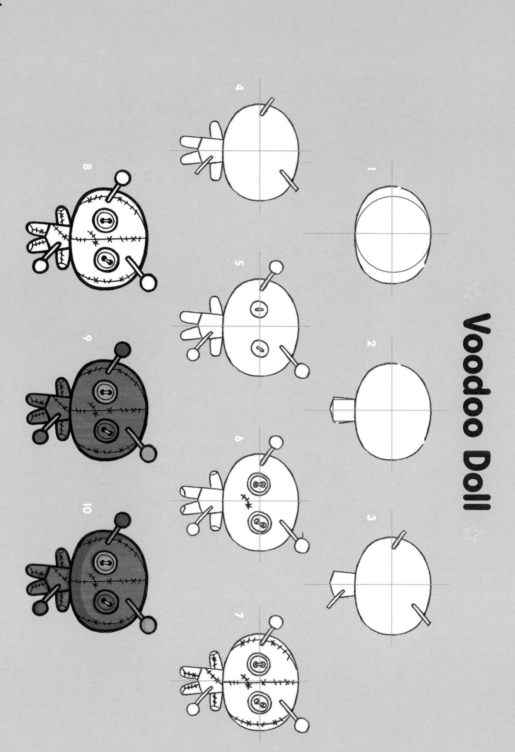

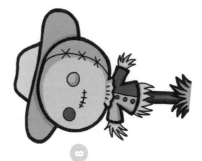

☆ Scarecrow ☆

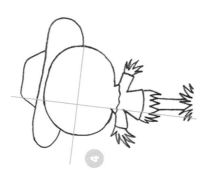

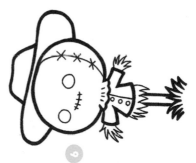

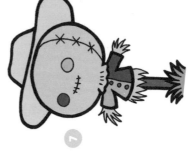

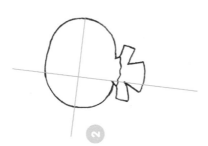

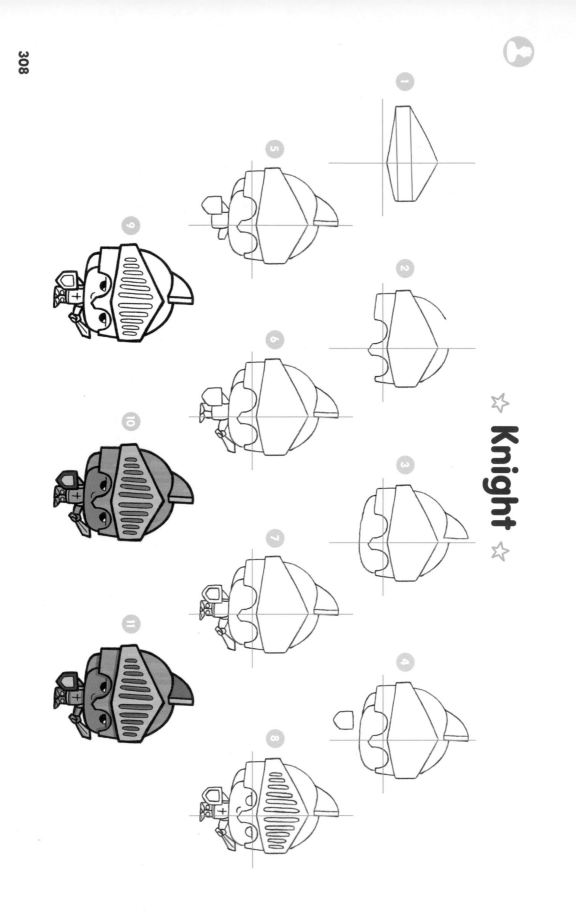

☆ **Knight** ☆

Princess

1

2

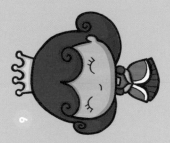

3

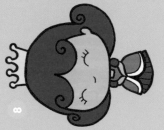

4

5

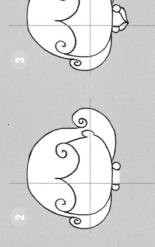

6

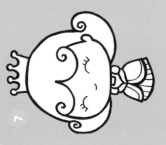

7

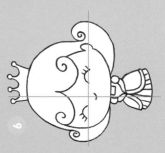

8

9

Pirate

1

2

3

4

5

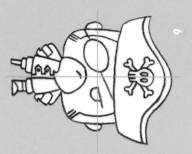 6

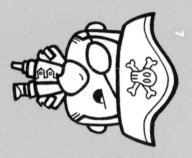

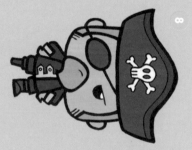

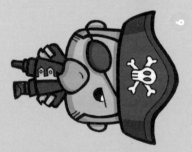

☆ Wizard ☆

Mermaid ☆

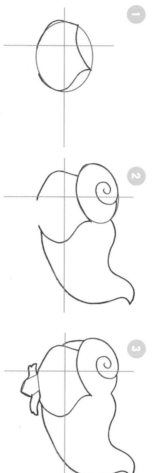

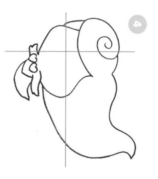

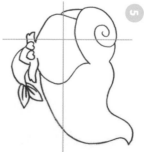

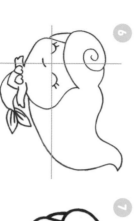

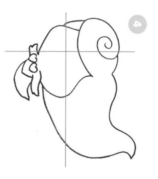

Fairy

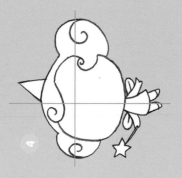

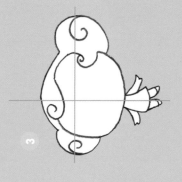

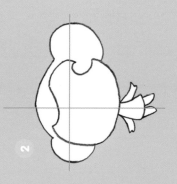

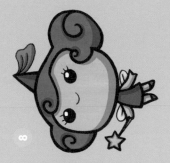

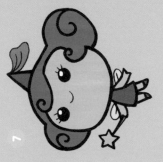

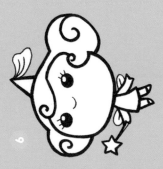

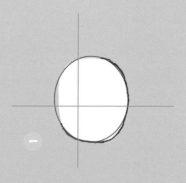

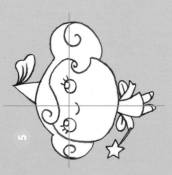

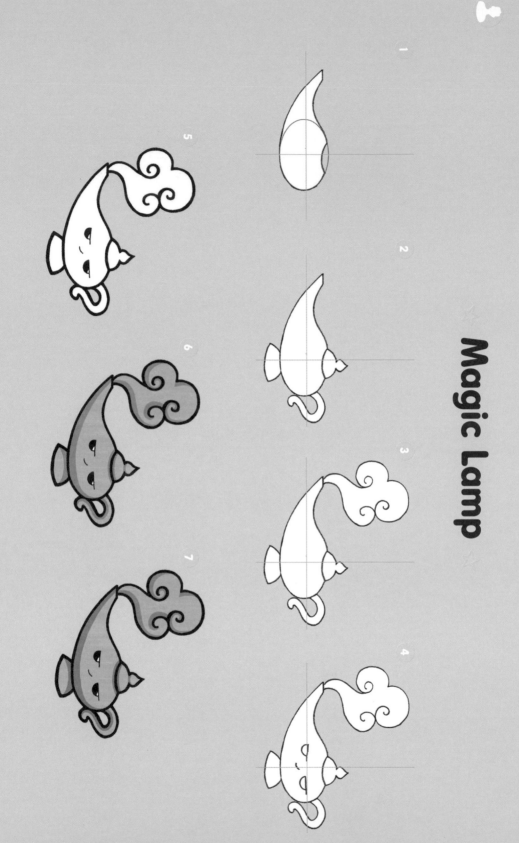

Magic Lamp

☆ Genie ☆

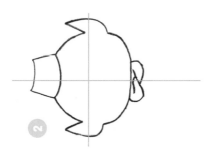

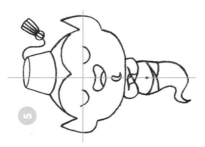

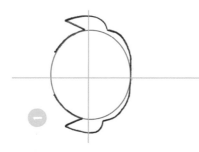

☆ **Explorer** ☆

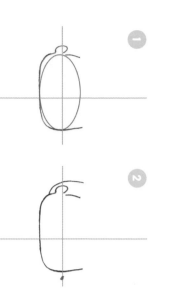

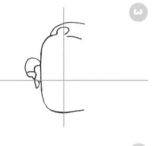

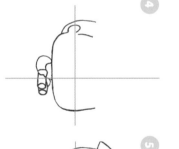

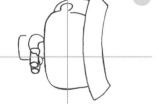

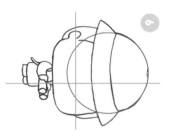

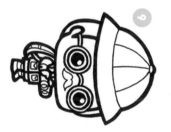

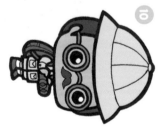

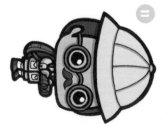

Mummy

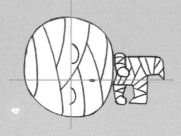
1

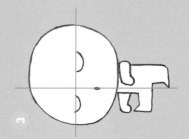
2

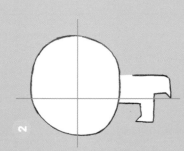
3

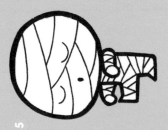
4

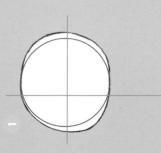
5

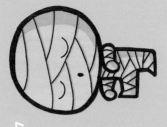
6

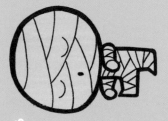
7

Pharaoh

1
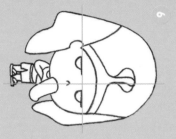

2
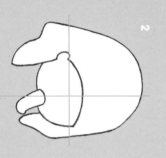

3

4
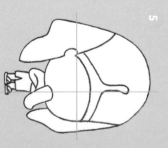

5
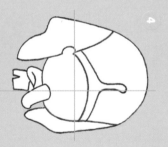

6
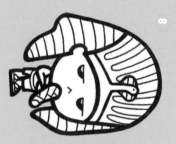

7
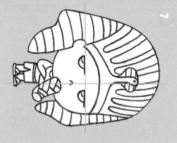

8
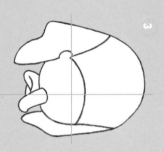

9

10

☆ Cleopatra ☆

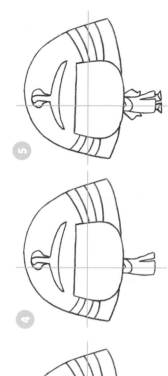

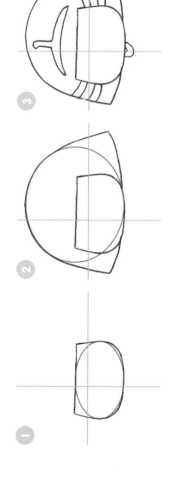

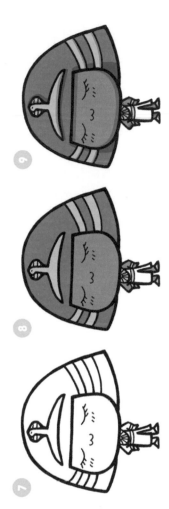

☆ **Pink Kokeshi** ☆

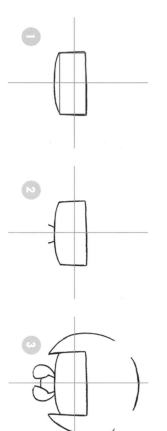

Blue Kokeshi

1

2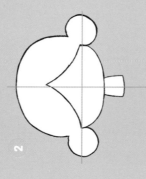

3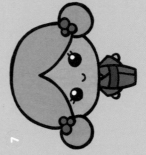

4

5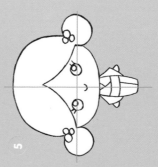

6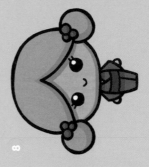

7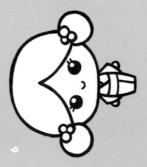

8

Green Kokeshi

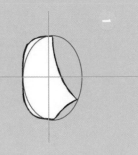

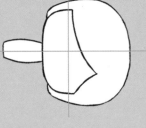

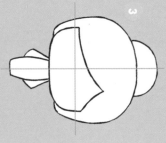

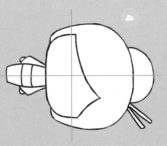

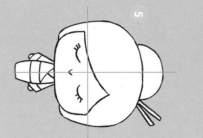

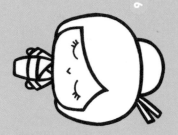

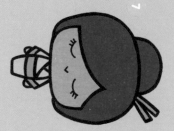

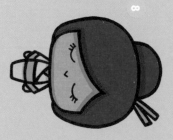

☆ Red Kokeshi ☆

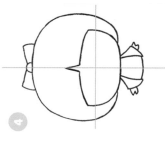

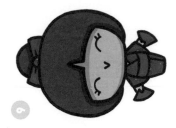

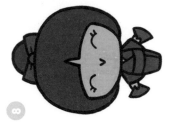

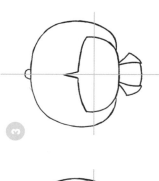

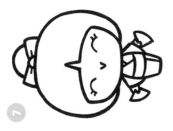

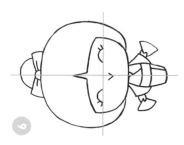

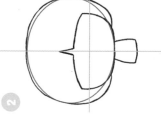

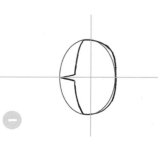

☆ Goth Girl ☆

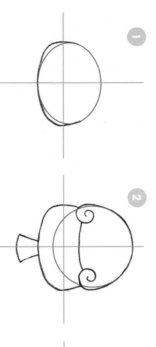

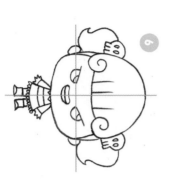

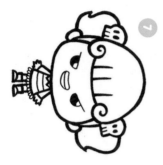

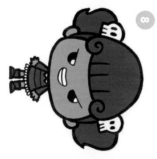

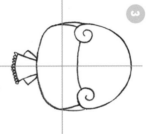

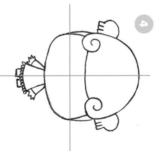

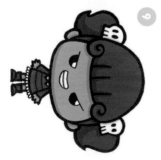

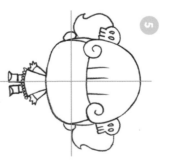

Rabbit Boy

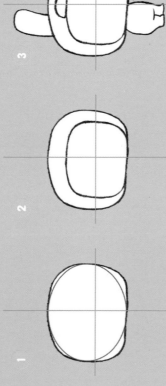

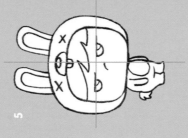

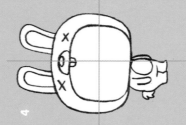

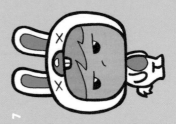

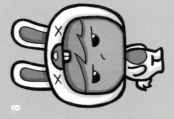

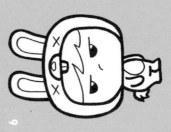

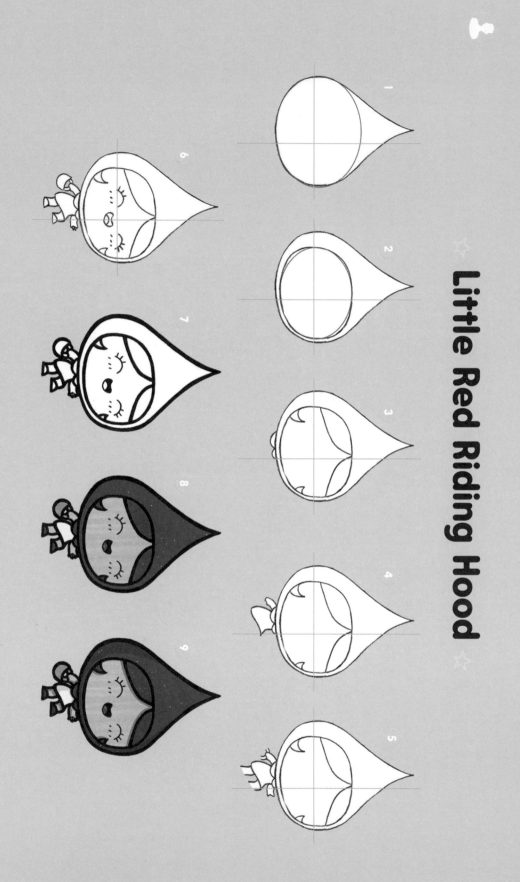

Little Red Riding Hood

☆ Ballerina ☆

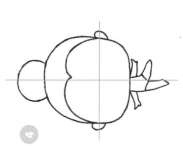

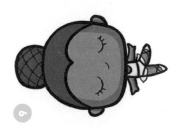

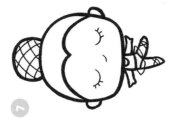

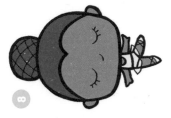

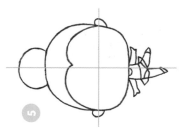

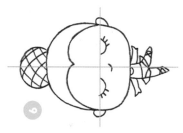

☆ **Chef** ☆

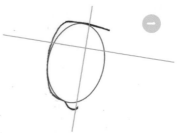

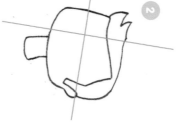

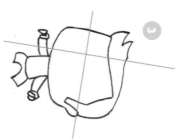

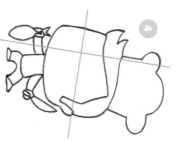

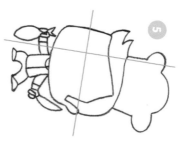

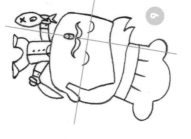

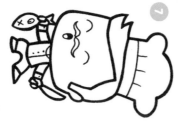

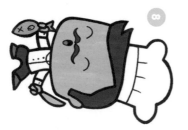

Astronaut

1

2

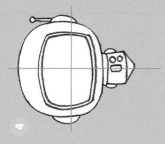

3

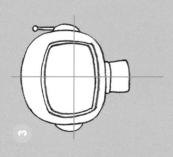

4

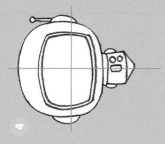

5

6

7

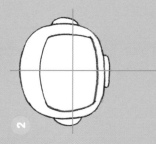

8

9

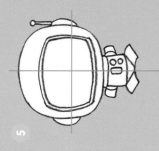

10

Alien

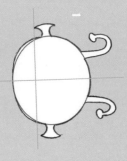

1

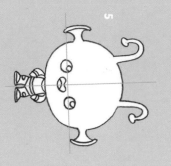

2

3

4

5

6

7

8

☆ Flying Saucer ☆

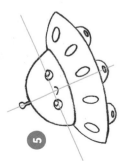

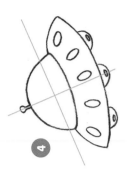

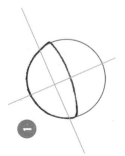

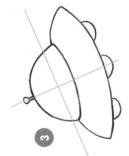

Rocket ☆ ☆

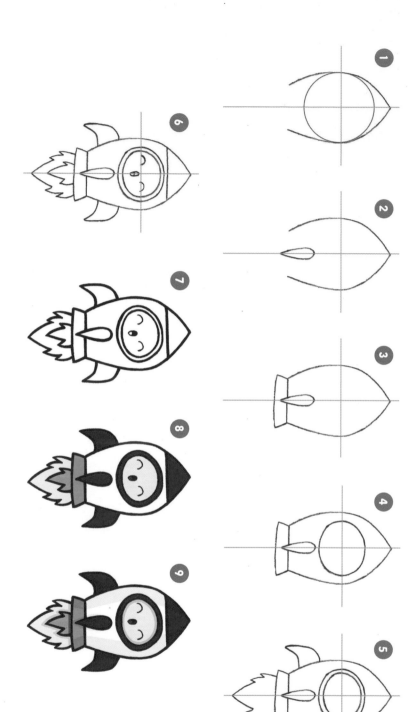

☆ Aeroplane ☆

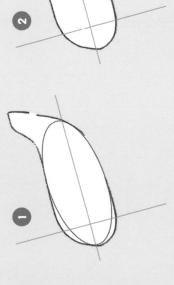

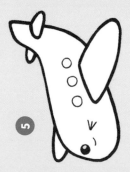

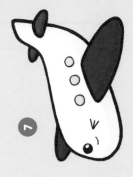

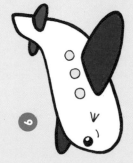

☆ Hot Air Balloon ☆

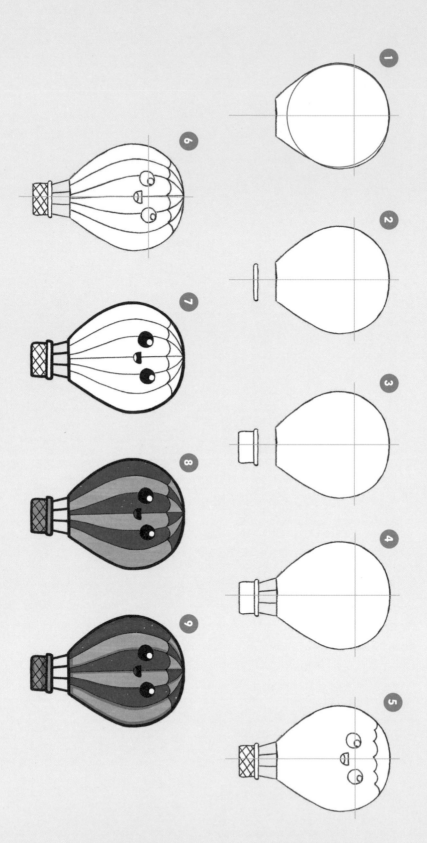

Helicopter ☆

☆

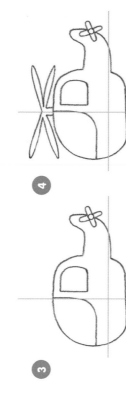

2

3

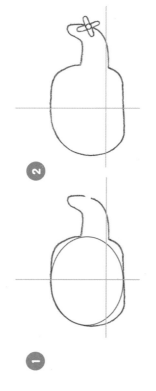

1

4

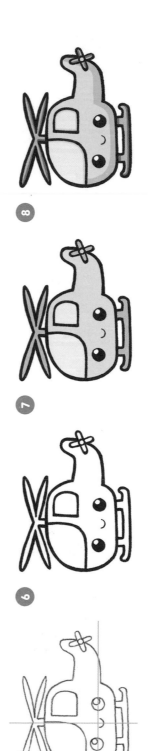

5

6

7

8

Fire Engine ☆

☆

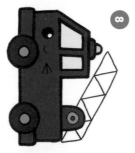

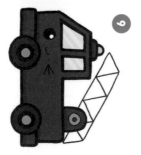

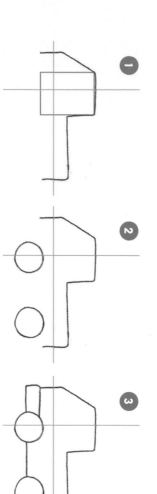

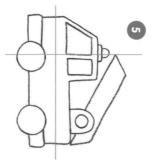

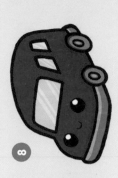

☆ Car ☆

1

2

3

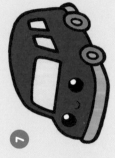

4

5

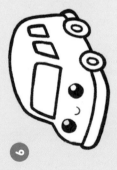

6

7

8

Scooter

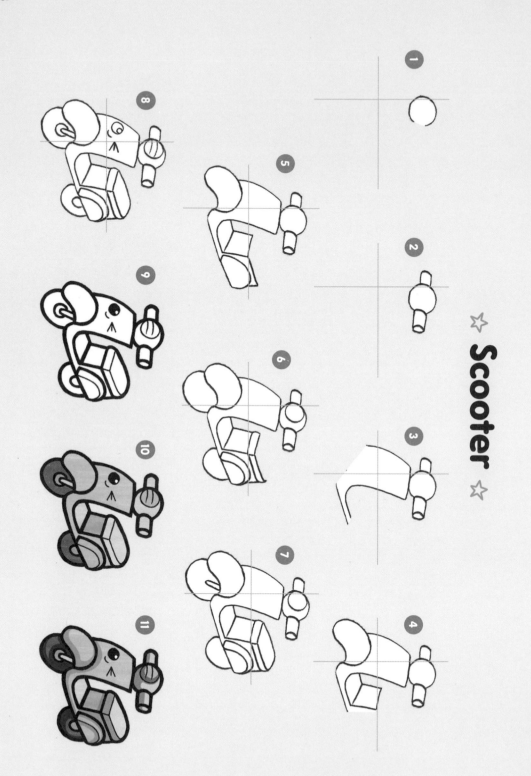

☆ Gondola ☆

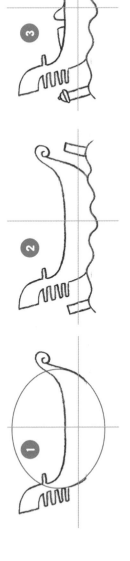

Sailing Boat

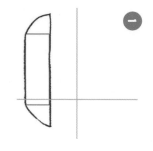
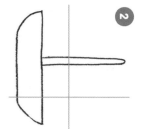
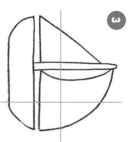

☆ Pirate Ship ☆

1

2

3

4

5

6

7

8

9

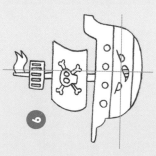

☆ Cruise Ship ☆

1

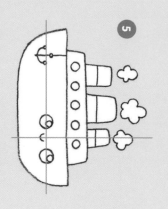

2

6

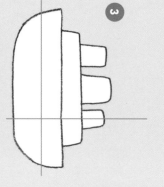

3

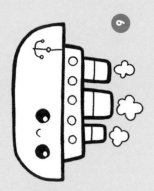

4

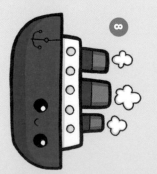

5

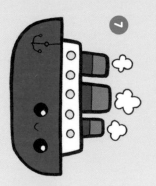

8

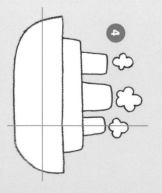

7

Submarine ☆

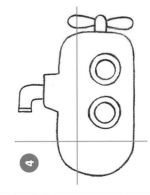

1

2

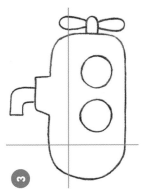

3

4

5

6

7

8

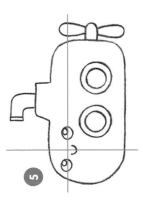

Desert Island ☆ ☆

1

2

3

4

5

6

7

8

9

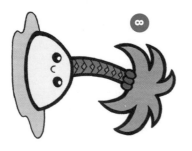

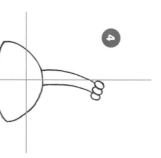

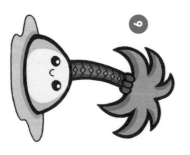

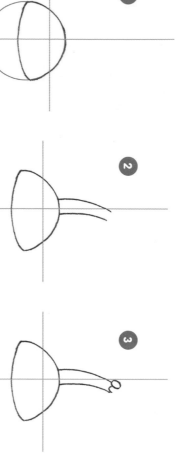

☆ Tepee ☆

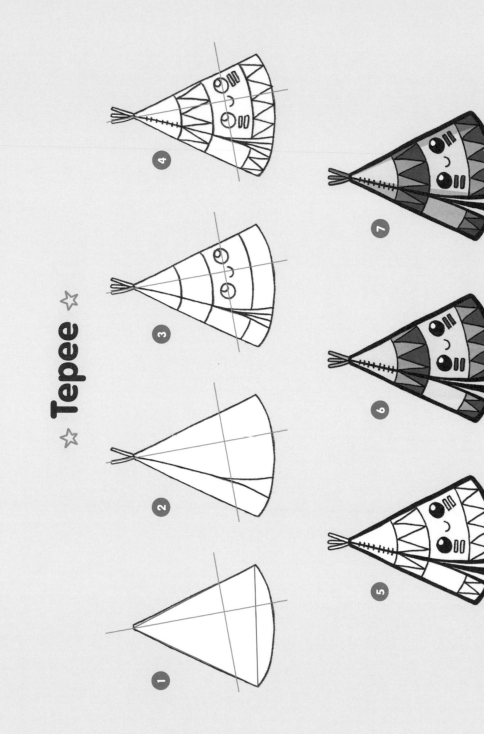

☆ Circus Tent ☆

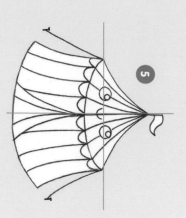

1

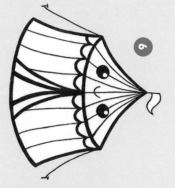

2

3

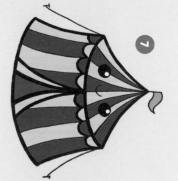

4

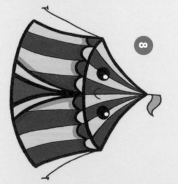

5

6

7

8

Windmill

☆ **House** ☆

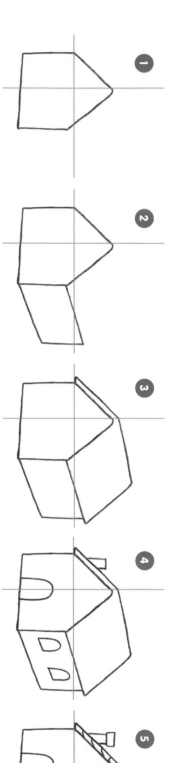

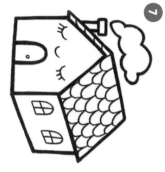

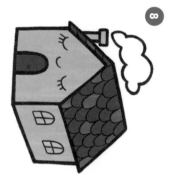

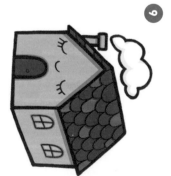

☆ Castle ☆

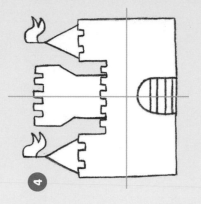

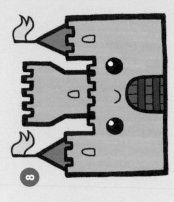

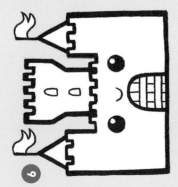

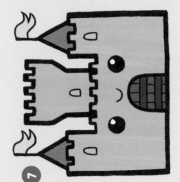

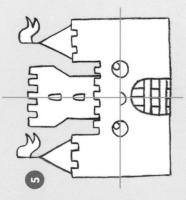

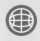

350

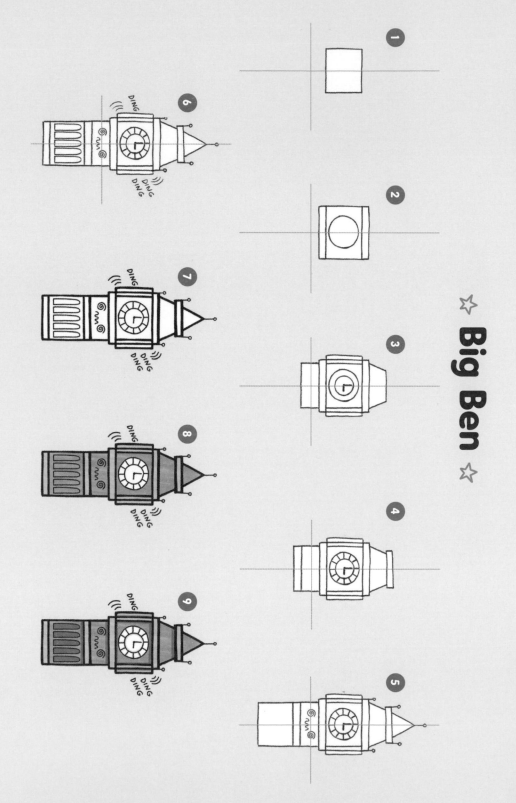

☆ **Big Ben** ☆

Leaning Tower of Pisa

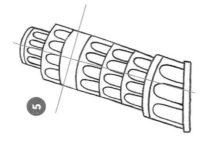

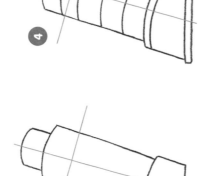

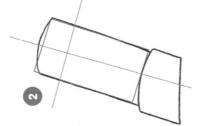

Eiffel Tower

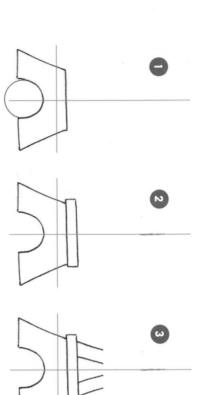

1

2

3

4

5

6

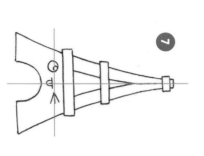

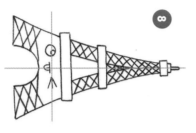

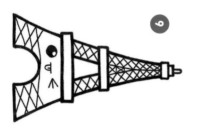

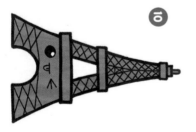

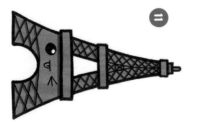

7

8

9

10

11

☆ Statue of Liberty ☆

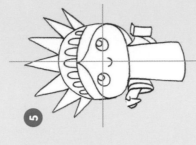

1

2

3

4

5

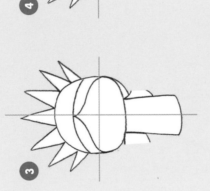

6

7

8

9

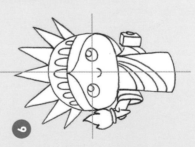

☆ Pyramids ☆

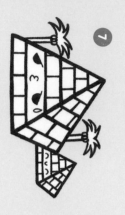

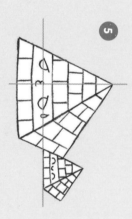

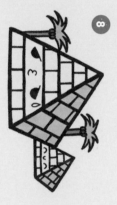

Sun

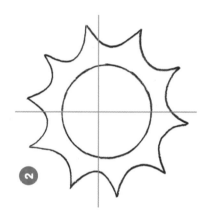

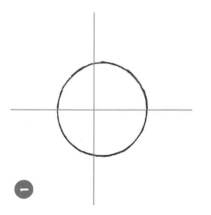

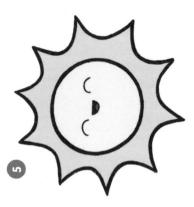

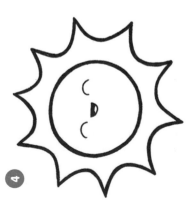

Sun, Clouds and Rainbow

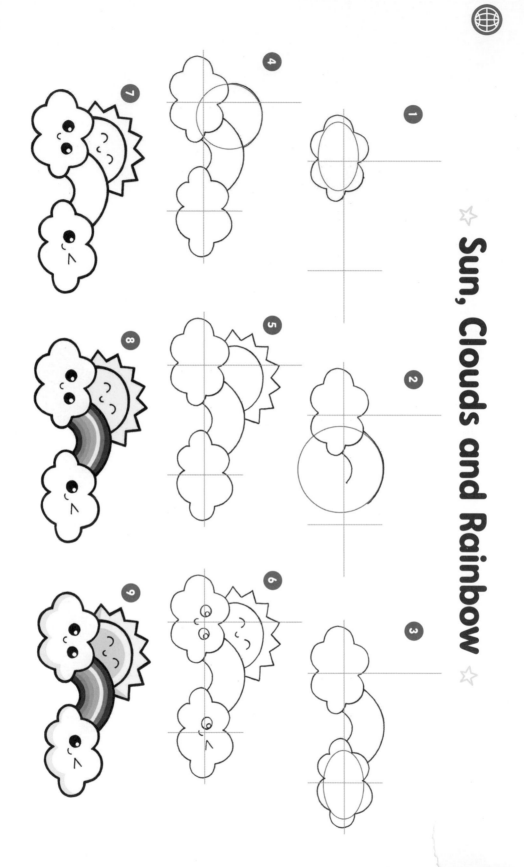

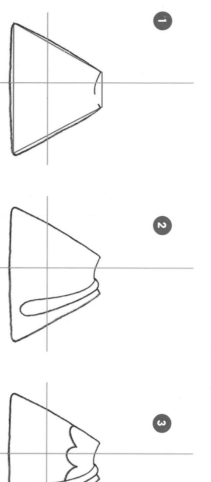

Volcano ☆

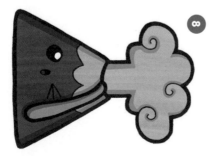

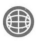

Fire ☆ ☆

3

6

2

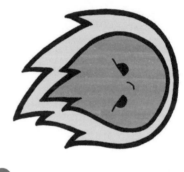

5

1

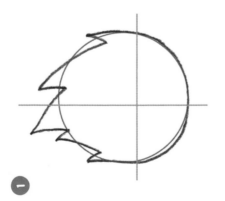

4

☆ Tornado ☆

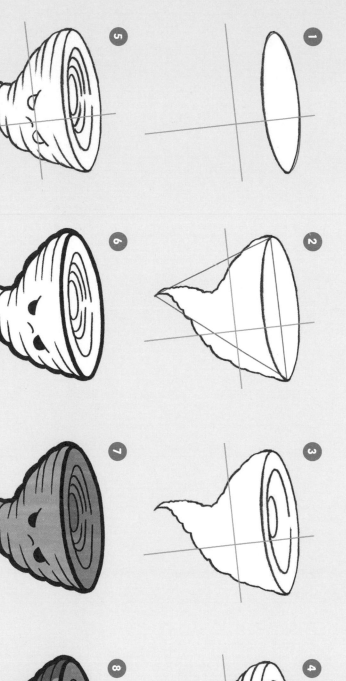

☆ Rainclouds, Rain and Lightning ☆

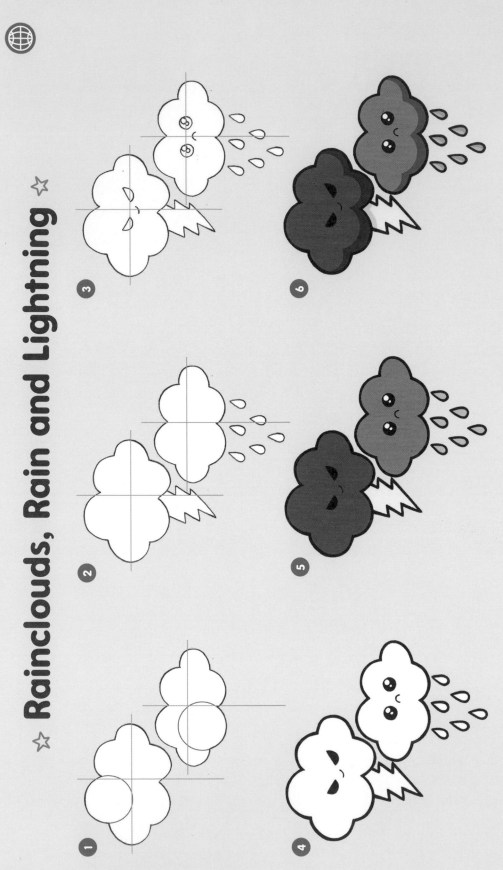

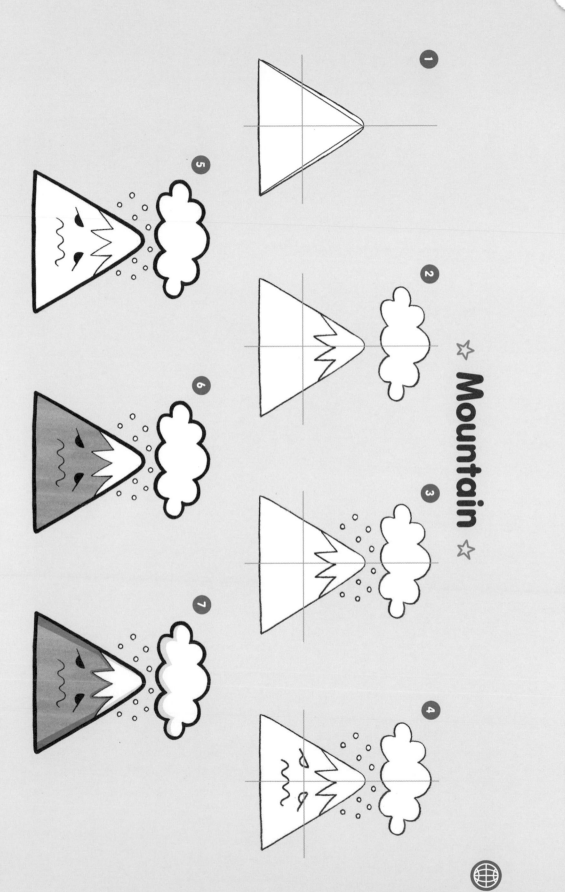

☆ Mountain ☆

1
2
3
4
5
6
7

☆ **Wave** ☆

3

2

1

6

5

4

Water Droplet

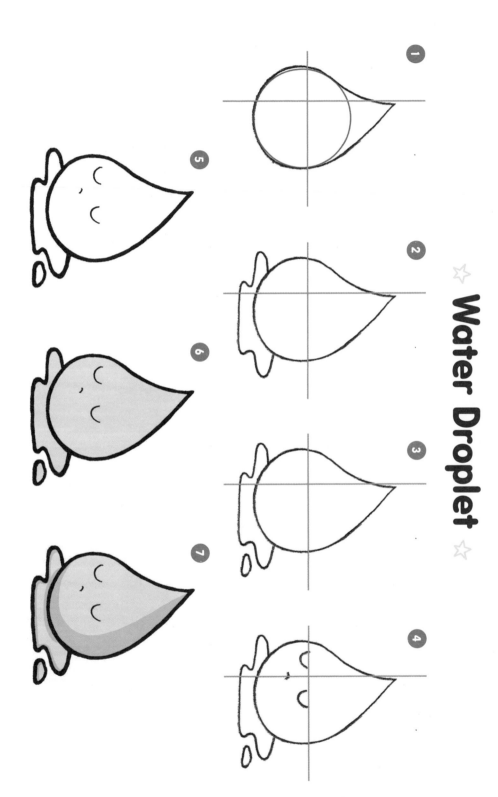

Earth ☆ ☆

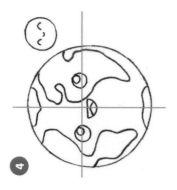

1

2

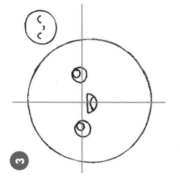

3

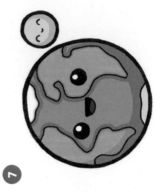

4

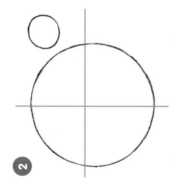

5

6

7

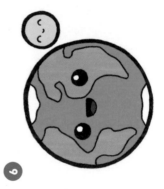

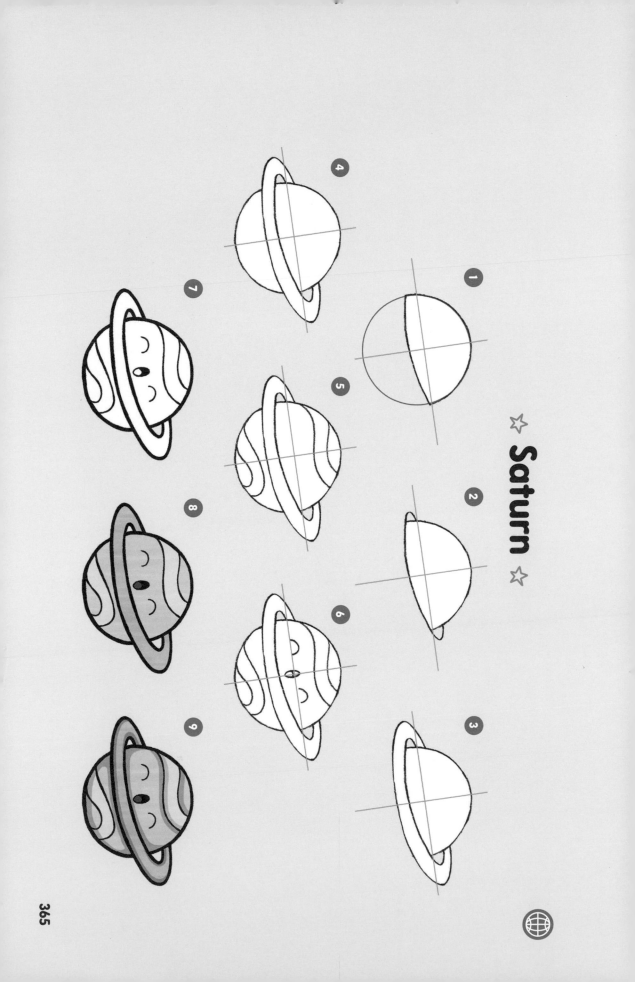

☆ Saturn ☆

365

☆ Meteor ☆

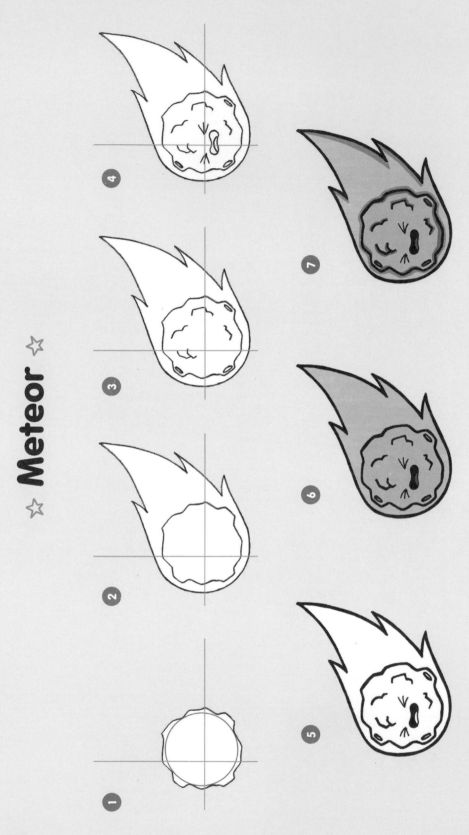

Shooting Star

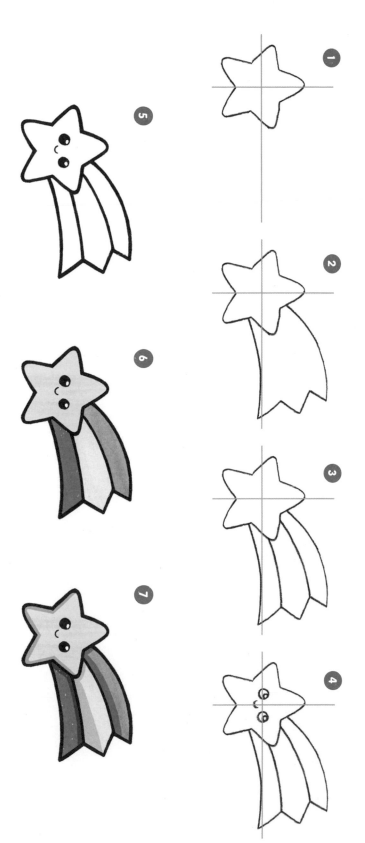

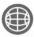

Moon

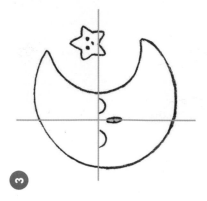

3

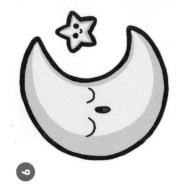

2

1

6

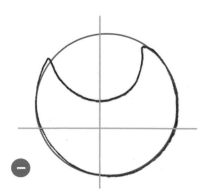

5

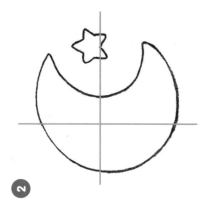

4